THE MEGALITHIC ART OF THE MALTESE ISLANDS

MICHAEL RIDLEY

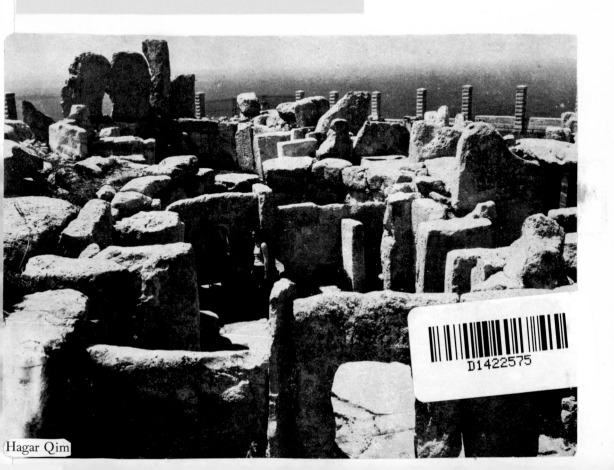

Hagar Qim

Dolphin Archaeologies

Prehistoric Rock Art of Argyll by Ronald W. B. Morris

Mesolithic Cultures of Southern Britain by S. Palmer

New Grange by George Coffey

CONTENTS

Spelling, Accents and Pronunciation

For simplicity accents for Maltese words have not been included, as it is felt that they may confuse rather than aid the reader. However the following Maltese names are pronounced as follows:- Hagar Qim — *Hajar Yim;* Mnajdra — *(M)Naidra;* Tarxien — *Tarshin;* Tas Silg — *Tas Silj;* Hal Saflieni — *as spelt;* Zebbug — *Zebooj;* Tal Qadi — *Tal Ardi;* Xrobb il Ghagin — *Srob il Ahgin;* Bugibba — *Bujeeba;* Ggantija — *Jaguntiya;* Ghar Dalam — *Ahr Dalaam;* Skorba — *as spelt.*

FOREWORD

by FRANCIS S. MALLIA, Dip. Archaeol. (Lond.), F.S.A. Scot.
Director, National Museum of Malta

The first examples of a vast corpus of relief carvings which adorn a number of the limestone blocks in some of the megalithic temples of the Maltese islands were found early in the 19th century during excavations at Ggantija on Gozo, and later at Hagar Qim on Malta. The bulk, however, were not discovered until the investigation of the Tarxien temple complex by Sir Themistocles Zammit in the second decade of this century. Since then other carvings have come to light on other sites in Malta, including reliefs from Bugibba on the north east coast, an engraved fragment of limestone from nearby Tal Qadi, and a head of a statue-menhir from Zebbug. More recently a large statue of a mother goddess with a spiral relief on the base was recovered from excavations at Tas Silg.

This descriptive inventory of Maltese megalithic art constitutes an important advance in the study of an aspect of the islands' prehistoric culture which has in the past received only sporadic and superficial attention. Mr. Michael Ridley has brought together for the first time all the relief carvings, the engravings and the paintings from both the surface temples and the rock-cut Hypogeum.

At a time when Maltese archaeology is making great strides forward, this contribution comes as a welcome and useful addition to our knowledge, and should help our appreciation and understanding of a culture which achieved such great proficiency in the fields of megalithic architecture and the art which goes with it.

Notes and Abbreviations

Text notes and references in this book have been placed beside the text to which they refer. Abbreviations where used refer to publications listed in the bibliography at the back of the book.

ACKNOWLEDGMENTS

The writer is deeply indebted to a number of persons and organisations, without whose wholehearted co-operation over the last five years, this work could never have been completed.

I would like to record my gratitude and thanks to the authorities of the National Museum of Malta, in particular to Mr. Francis Mallia, the Director, for his help and encouragement, who as Curator of Archaeology, when this work was undertaken, provided every assistance and facility. My thanks are also due for permission to trace and reproduce parts of two drawings of the Ggantija temples by H. von Brocktorff.

I received every co-operation from the custodians of the various sites and site museums, and would like to thank in particular Mr. H. Agius, Mr. J. Ellul, and Mr. A. J. Agius.

Assistance and co-operation was received from a number of people, too numerous to mention, but whom I hope will accept my grateful thanks.

Finally, my wife, Jacqueline Ridley, deserves special mention, for without her assistance, both in the field and in the preparation of the manuscript, this work would not have seen the light of day.

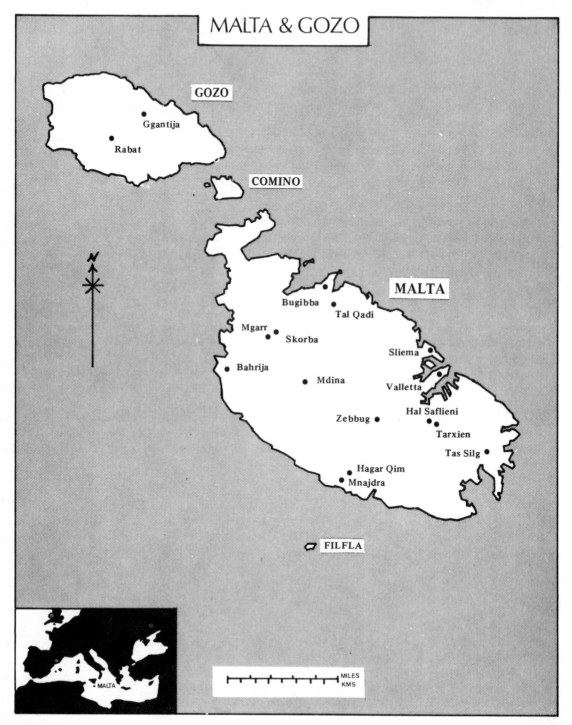

MALTA & GOZO

GOZO

Ggantija

Rabat

COMINO

MALTA

Bugibba

Tal Qadi

Mgarr

Skorba

Sliema

Bahrija

Mdina

Valletta

Hal Saflieni

Zebbug

Tarxien

Tas Silg

Hagar Qim

Mnajdra

FILFLA

MALTA

MILES
KMS

PREHISTORIC MALTA

Malta, with an area of 93 square miles, is the largest of a group of islands which lie approximately 60 miles S.E. of Sicily. Of the other three, Gozo is the largest, with an area of 26 square miles.

Formed during the Oligocene and Miocene periods of the Tertiary epoch, the islands consist of limestone, Upper Coralline, Globigerina and Lower Coralline. Deposits of greensand and blue clay are also found. Although there are traces of Quaternary deposits, most have eroded.

The ready supply of limestone on the islands probably helped more than anything else to kindle the great megalithic tradition which developed there. The early megalith builders quickly recognised the properties of the limestone and utilised these properties to great effect in the massive structures.

Globigerina can easily be cut into shape and elaborate carvings made. Although soft, when used as building material and exposed to the weather, it quickly develops a protective skin, which is very strong. The Coralline limestone, however, was best suited to megalithic architecture. It is harder than Globigerina and has a tendency to split both horizontally and vertically, thus producing natural 'megalithic' slabs.

There are approximately 30 megalithic sites on the islands and although they vary somewhat in size it is possible to trace the gradual evolution of ground plan from the essentially simple cell to the large 'temple' complex of Tarxien and Hagar Qim.

Façade of the megalithic temple of Hagar Qim.

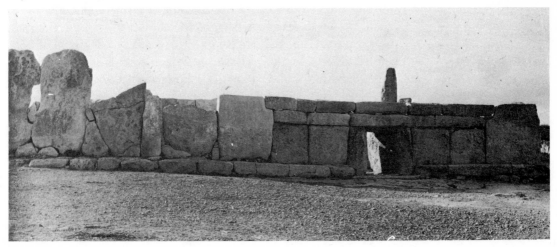

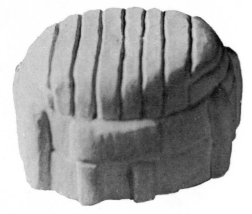

Miniature limestone model of a megalithic single cell building, found at Mgarr. Length 50 mm.

This block is 6.77 m long.

Although termed megalithic, they contain many cyclopean features. Ggantija, for example, is a marriage of both forms of construction. The stones vary in size from small boulders to large megalithic slabs, such as the one used in the outer wall at Hagar Qim, which is the largest of all stones used in the 'temples.'

The oldest surviving megalithic structures in Malta are of simple trefoil plan, though it is possible that the earliest were of a single chamber. This is indicated by a small limestone model of a single cell building found at the 'temple' of Mgarr. Although buildings of trefoil plan appear to be the earliest they are still found at the last phase of 'temple' building.

Simple trefoil plans are also found at Kordin, at Mnajdra (next to the large complex), at Skorba, and again at Tarxien, outside the main 'temple' complex. It is possible, however, to see the shape progressing for enlargement from the relatively simple trefoil shape to a more complicated design of passage with transepts on to the existing trefoil shape.

This can be seen clearly in the South Temple at Ggantija in Gozo. Here we have the two front transepts smaller than the rear. This is unusual, as the transepts nearly always decrease in size towards the end of the passage, not vice versa. It is possible that here we have an addition or afterthought to the existing trefoil shape. The North Temple adjacent, built later, conforms to the usual plan. Many of the 'temple' complexes have been rebuilt and enlarged at various times.

It might, therefore, be more correct to describe the trefoil shape as the smallest unit, rather than the earliest. It is possible to see the small unit enlarged by one or more pairs of transepts leading off a passage. Further enlargements can be seen when one or more of these enlarged units are bound together with a common outer wall.

12

Interior of the outer transept lower temple of Mnajdra, showing layers of corbelling.

Some authors have described the transept chambers as apses. Although the term apse has been established, by its use over a number of years, the present writer feels that the term transept more accurately conveys the appearance of the chambers and has adopted it for use throughout the book.

The basic plan common to all 'temples' is a passage from which pairs of transepts branch off. Sometimes, because of alterations at later dates, this is extremely difficult to recognise. The chambers are walled with orthostats, the floors are of Torba, beaten and polished limestone powder, or occasionally limestone flags. The Ggantija Temple has the transepts walled in a more cyclopean technique, although the outer wall is composed of giant megalithic slabs. As with all the 'temples,' the space between the inner and outer wall is filled with earth and rubble.

A feature some 'temples' have in common with the megalithic chamber tombs of Western Europe is the porthole slab, dividing the transept from the passage or sometimes dividing the transepts themselves. These stones are truly impressive—some well over 2.13 mts. high, with square-cut openings 90 cm. x 60 cm. approx.

Ground plan of the West Kennet long barrow typical of the Severn Cotswold group of megalithic tombs.

General view of Hagar Qim showing a porthole slab.

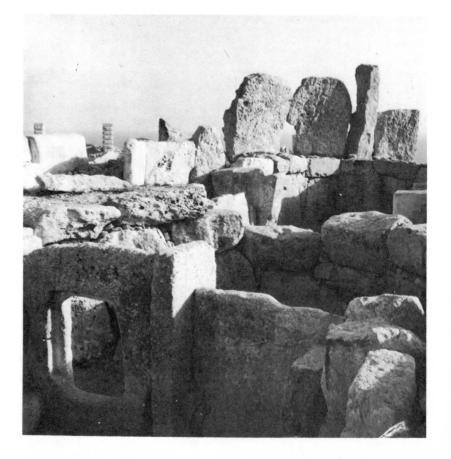

The best preserved of all structures is the unique Hypogeum of Hal Saflieni, near the Tarxien 'temples.' Although not truly a megalithic structure, it must be considered together with the surface 'temples.' A large complex of underground chambers on several levels, carved out of the living rock, it preserves many unusual features and gives the impression of a large underground cemetery or ossuary. The best parallels are found at the Anghelu Ruju cemetery in Sardinia. One of these has an internal façade, though it is smaller and simpler than the Maltese example.

The large chamber or hall of the Hypogeum preserves all the features of the surface structures carved in the bedrock. Chambers, too small to admit a man, open off the hall. These are probably ossuaries. The architectural features include trilithons and corbelling. The features seen in the Hypogeum reflect accurately the surface architecture and, because carved in the rock, have remained as a guide for the interpretation of the surface structures.

Interior of the Hypogeum of Hal Saflieni showing carved imitations of corbelled roofing and trilithon doorways.

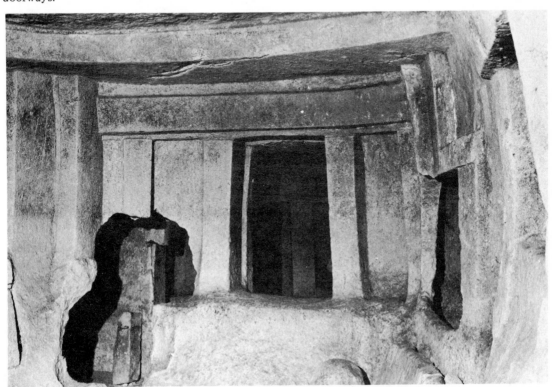

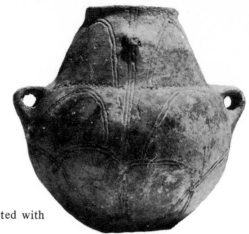

MNI pot from Zebbug decorated with cut-out bands.

In the past few years a great deal of new evidence has been brought to light on the megalithic culture of Malta, which has resulted in changes in the chronology of the different phases which Professor J. D. Evans put forward in his book 'Malta,' which he had based mainly on the typology of the pottery sequences.

Since the publication of this book in 1959, David Trump has carried out excavations on the site of Li Skorba, which not only resulted in the discovery of two new phases in the Maltese sequence, that of Grey Skorba (3600 B.C.) and Red Skorba (3400 B.C.) (both associated with settlement sites which pre-dated the temples), but also a new absolute date based on radiocarbon dating. This and radiocarbon dating carried out on material from other sites has necessitated a change in absolute dates. Trump's excavations showed that Evans' sequence of Mgarr-Zebbug would

SKB p. 17-20.

have to be reversed. This was proved by a series of soundings at the sites of Kordin III, Ta Hagrat, and Santa Verna on Gozo.

Trump also favours a return to the terms 'Neolithic' for Ghar Dalam, together with the Grey Skorba and Red Skorba phases, and introduces the term 'Copper Age' for the Zebbug, Mgarr, Ggantija, Saflieni (a sub-division of Tarxien, also advocated by Trump) and Tarxien. This he bases on the similarity with the contemporary Sicilian Copper Age. The old Period II reverts to its old title of Bronze Age with the added term Iron Age.

NCM

Evans' period IA, Ghar Dalam, now dates to c. 4200 B.C. Evans had previously suggested that it was not before 2500 B.C. Two new phases are introduced, those of Grey Skorba and Red Skorba, Trump's radiocarbon date for the Red Skorba phase is 3225±150

SKB p. 48.

B.M.148 (radiocarbon number). SKB p. 20.

B.C. Trump also separates these first three phases from the later ones and calls them Neolithic, while the others he places in the Copper Age.

The old sequence Mgarr and Zebbug is now reversed. Trump obtained radiocarbon dates of 3190 ± 150 B.C. and 3050 ± 150 B.C. for Zebbug. His date for this period is now 3200 B.C. Evans published a radiocarbon date of 2700 B.C. for the Mgarr phase, but this has been found to be inconsistent; the source more probably Ggantija. Evans' phase I D. Ggantija, can now be dated to c. 2700 B.C. Trump obtained a false radiocarbon date of 3290 ±150 B.C. A new phase of Saflieni is introduced by Trump c. 2400 B.C.

Tarxien, Evans' phase I E, dated to 1600 - 1500 B.C. Trump's new date is 2400 B.C., his radiocarbon date being 2430 ± 150 B.C.

Evans' period IIA, The Tarxien Cemetery (Bronze Age), which he dated to 1400 B.C., Trump dates to 2000 B.C., his radiocarbon date being 1930 ± 150 B.C. He also had a false radiocarbon date of 2535 ± 150 B.C. Evans' date for Borg in Nadur (his IIB) was 1300 - 1200 B.C. His date for Bahrija (IIC) was 1100 - 800 B.C. These still stand, as we do not have any further new dates.

On examination the Copper Age is more truly Neolithic in character. No copper tools have been found with any of the phases associated with the 'Copper Age.' Although the term makes it possible to tie in the Maltese sequence with the Sicilian, descriptively it is still misleading as the Sicilian 'Copper Age' is also copperless. I therefore propose that it would be more in keeping to use the descriptive term, Neolithic, which accurately reflects the condition of the culture.

When Trump advocated the abandonment of Evans' system of chronology in 1966, he criticised the use of numbered and lettered phases, and suggested the use of letters abbreviating the names of the type sites. Evans in his review of Skorba in Antiquity lamented the return to a three-age system, and the introduction of a copperless ' Copper Age,' but admitted that it might have been confusing to re-number the phases at that stage (1966).

Time has passed, all new radiocarbon dates have been assessed and I suggest we are now ready for the introduction of a system that will also allow expansion and elaboration as and when new advances are made. There are a number of ways in which this could be done. One of these is set out below by the present writer, who hopes that it will promote discussion and criticism allowing a more comfortable system for the Maltese chronological sequence to be arrived at.

B.M.145 (radiocarbon number).

B.M.147 (radiocarbon number).

B.M.100 (radiocarbon number). Antiquity Vol. XXXV, No. 138, p. 143. SKB p. 17, 48.

B.M.142 (radiocarbon number). SKB p. 48.

SkMM p. 303.

B.M.143 (radiocarbon number). SKB p. 48.

B.M.141 (radiocarbon number).

B.M.101 (radiocarbon number). Wood excavated by T. Zammit from Tarxien. SKB p. 48.

The system suggested would involve the division of the Neolithic period into three phases—early, middle and late, each phase in turn being divided numerically. The Bronze Age would be treated likewise.

Trump's Neolithic, which includes Ghar Dalam, Grey Skorba and Red Skorba, would become Early Neolithic I, II, and III respectively. The phases Zebbug and Mgarr would become Middle Neolithic I and II respectively. The phases Ggantija, Saflieni and Tarxien would constitute the Late Neolithic I, II and III respectively. The Bronze Age would be divided into Early Bronze Age I, Tarxien Cemetery; Middle Bronze Age I, Borg in Nadur; Late Bronze Age I, Bahrija. All phases in this book will be described using this system.

I now propose to take all the new evidence into account, and suggest a chronological table as follows:

PERIOD		Abbrevia-tion	TYPE SITE	RADIOCARBON DATE	Suggested Chronology		Evans (59) Period	Trump (66) Period
Early Neolithic	I	ENI	Ghar Dalam	4190 ± 160 B.C. (B.M.378)	4200	B.C.	IA	Gh.D.
				3810 ± 200 B.C. (B.M.216)				
Early Neolithic	II	ENII	Grey Skorba	* * *	3600	B.C.	*	G.Sk.
Early Neolithic	III	ENIII	Red Skorba	3225 ± 150 B.C. (B.M.148)	3400	B.C.	*	R.Sk.
Middle Neolithic	I	MNI	Zebbug	3190 ± 150 B.C. (B.M.145)	3200	B.C.	IC	Zb.
				3050 ± 150 B.C. (B.M.147)				
Middle Neolithic	II	MNII	Mgarr	2700 ± 150 B.C. (B.M.100)	2900	B.C.	IB	Mg.
Late Neolithic	I	LNI	Ggantija	3290 ± 150 B.C. (B.M.142)	2700	B.C.	ID	Gg.
Late Neolithic	II	LNII	Saflieni	* * *	2400	B.C.	*	Saf.
Late Neolithic	III	LNIII	Tarxien	2430 ± 150 B.C. (B.M.143)	2300	B.C.	IE	Tx.
Early Bronze Age	I	EBI	Tarxien Cemetery	2535 ± 150 B.C. (B.M.101)	2000	B.C.	IIA	T.C.
				1930 ± 150 B.C. (B.M.141)				
Middle Bronze Age	I	MBI	Borg in Nadur	* * *	1400	B.C.	IIB	B.N.
Late Bronze Age	I	LBI	Bahrija	* * *	1100	B.C.	IIC	Bah.

MEGALITHIC ART

Painted ceiling from the 'Oracle's Chamber' of the Hypogeum of Hal Saflieni showing spirals of the 'tree of life.' *Detail.*

The megalithic art of the Maltese islands may be divided into two parts, based on medium; carvings mainly in relief and paintings. The majority are carvings, there being only one site that has produced paintings, Hal Saflieni.

The oldest work we have to date is the fragment of a statue menhir from Zebugg, which dates to the early fourth millenium B.C. This is unique in Malta, and therefore no local comparisons can be made except perhaps for the anthropomorphic figures on MNI pottery, and we have to look to Sicily, France, Iberia and perhaps the Eastern Mediterranean for any comparable examples, although none of them display a great deal of similarity. It must, therefore, be considered an indigenous creation.

The majority of the carvings come from the Tarxien 'temple' complex, the remainder from the Ggantija 'temples' on Gozo,

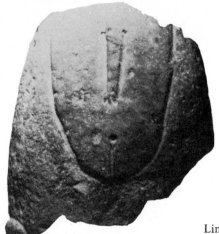

Limestone statue menhir from Zebbug.

Bugibba, Hagar Qim near Qrendi, with isolated examples from Tal Qadi, Tas Silg and Mnajdra. A number of buildings, however, have blocks decorated with drilled holes, often used as backgrounds to some of the relief carvings.

Basically the motifs can be divided into the following groups: (1) Curvilinear, derived from or consisting of spirals and circles. (2) Naturalistic representations of animals, fish, plants, etc. (3) designs other than categories 1 and 2 , mainly abstract.

Perhaps the most interesting are the curvilinear motifs; they are also the most prolific, the majority being at Tarxien, while others were found at Bugibba, Ggantija, Hagar Qim, Hal Saflieni (paintings) and Tas Silg.

The basic component of these designs is the spiral. It appears in a number of forms as double opposed spirals arranged as oculi [**1 and 2**, **6**, **12 and 21**], as combinations of single spirals, sometimes described as 'C' spirals [**28,74, etc.**], as 'S' spirals, including reversed and horizontal versions [**40, 24, 25, 45, 59,**]. The other components are derived from the spiral and may be described as

Developed form of horizontal 'S' spiral conjoined with a 'C' spiral and 'horns'. Third temple at Tarxien, block 64.

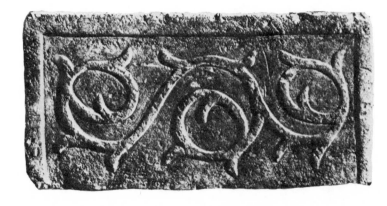

Horizontal 'S' spiral with 'horns'. Limestone relief carving from Tarxien, third temple, block **65**.

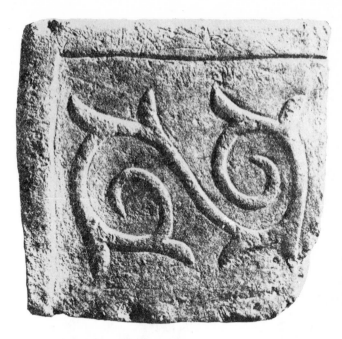

Painted ceiling from the 'Oracle's Chamber' of the Hypogeum of Hal Saflieni, showing spirals of the 'Tree of Life' and 'suns'.

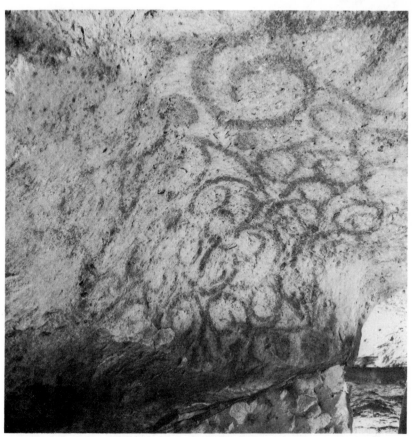

follows: Volute or semi-spiral, this is basically a spiral but whose turns have diminished and become looser [15, 18, etc], a stage between a true spiral and a 'C', which may be described as 'a','e' and 'o'. The 'a' is a curvilinear form in the shape of the letter, which has been developed by elongating the lower curve of a 'C' until it curves back on itself touching the main body [64], this is also found reversed [52]. The 'e' is similar to the 'a' but in this case it is the top curve which is elongated and curves downwards until it touches the main body [64], it too is found reversed [64]. The 'o' is also a development of the 'C', here both ends of the 'C' are elongated until they touch each other forming an 'o' [52, 44a].

These are the basic components, some form or forms of which constitute the main theme in most of the curvilinear reliefs or paintings. The circle is not common in Malta and is notable for its rarity. It is only found in the Hypogeum of Hal Saflieni on the ceiling of the 'Chamber of the Oracle' [18] and in the 'o' motif [52, 44a]. A variant, however, may be seen in the form of discs, which decorate the ceiling of the 'Chamber of the Oracle' [18], where they float among the branches (also in a niche in the same room); in the Room of the Hexagons [15], where a disc is surrounded by a semi-spiral within each hexagon; and also appears in the centre of the two carved screens at Tarxien [22, 23]. There is another on a fragment from Tarxien [67] and Murray reported a disc on a fragment of limestone from her excavations at Borg in Nadur.

The curvilinear forms mentioned above are joined together to form a variety of motifs, few of which duplicate the other, although they often give the illusion of being the same. These forms and compositions are often embellished with devices such as 'horns', small pointed projections which protrude from the curve of the spirals, 'C's' or similar shapes [28,44,64,65,etc] and 'tails',a description applied to the forked split ends of the 'C' or spiral, and which may occur at either end [29, 30, 58, 59,etc]. These were occasionally elongated to form vertical divisions between spirals [45] and ends to lines [27]. There is an example of a relief at Tarxien [40] which employs opposed 'tails' actually on the curve of the spirals, both top and bottom. From close examination of the motifs it may be suggested that the 'tail' is an artistic development of the 'horn', i.e. a 'double horn' [see 37 and

40] There are, however, other 'tails' long and thick which may be best described as 'trunks' [54, 55, 56, 43, 35, see also 18]. To these may be added two additional devices, concave and convex lines [1 and 2, 27] and 'V' wedges, seen on the screens and oculi blocks [1,2,6,12,22,23]. There are also panels such as [54], on which a 'Y' with forked stem becomes a tree trunk.

Perhaps the best clues to understanding the development and significance of the curvilinear forms can be found in the paintings on the ceilings of the Hypogeum [16 and 18] and the naturalistic reliefs of Bugibba [3 and 4], Hagar Qim [13] and Tarxien [53, 57, 68, 69,70]. In the Chamber of the Oracle [18], the ceiling conveys the impression of vigorous 'trees of life', full of nature's energy, sprouting in all directions, entwined until they conjoin. Most of the components found on the reliefs of the surface 'temples' are found here, but in this case it is easier to see their significance and relationships. Three 'trunks' are clearly visible off which shoot branches of thick spirals, from which in due course smaller spirals branch. The 'trunks' are similar to the 'trunks' on **54, 55, 56** at Tarxien, while the significance here of the spiral is self evident. The spiral then in this case appears to represent the

Painted ceiling showing volutes or semi-spirals and tendrils. Room of the Hexagons, Hypogeum of Hal Saflieni.

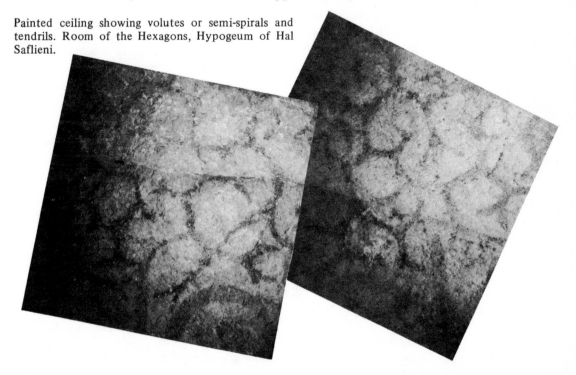

force and energy of nature, as represented by a vigorous tree which seems to be sending off shoots and branches in all directions. The 'discs' which float among the branches may represent the life force itself — the Sun. In examining these murals however, we must always bear in mind that they are a decorative art, and artistic licence is used to the full, but, nevertheless, they are religious art and embody elements of contemporary religious philosophy.

Further clues may be had by examining the motif of the ceiling of the Room of the Hexagons [16]. Here no attempt has been made to represent the 'trunks', instead a mass of entwined branches, shoots and tendrils decorate the ceiling, eventually joining with the wall motif of 'discs', which is surrounded by a volute branching from the corners of a honeycomb. The motif on this ceiling appears to be a development of the motif on the ceiling of the Chamber of the Oracle [18], and, therefore, later. This is supported by reference to the surface reliefs. However, although later, this is only relative, in that it is impossible to say how long the interval between the two paintings may have been. It could have been years, but, on the other hand, it may only have been months. Paintings tend to evolve, a fact illustrated by the work of almost any painter. Ideas developed in one painting may be incorporated and further developed in another. This is possibly the case with both the relief carvings and the paintings. Although not necessarily the work of one man, ideas developed in one work may be used again in another, with or without further modifications.

The ceiling of the Room of the Hexagons [16] is interesting as it has additional features not seen on the ceiling of the Chamber of the Oracle [18], but which are present on some relief carvings of the surface 'temples'. The 'horn' is present here, appearing to be the shoot or split of the stem or branch of the plant, the 'tail', the split end of the stem or branch, and the tendrils (small spirals or volutes). The impression is one of a vast meandering creeper or vine. The discs are important here. Set into a honeycomb, each seems to draw a tendril towards it, much as a plant is attracted towards light and warmth.

Above: Minoan seal stone showing pillar altar with plant on top.

Plants appear to have played an important part in the religion of the time, and acted as a very strong stimulus to art. This is further supported by a pillar 'altar' found at Hagar Qim [13]. Here a naturalistic relief carving of a plant growing from a tub fills all

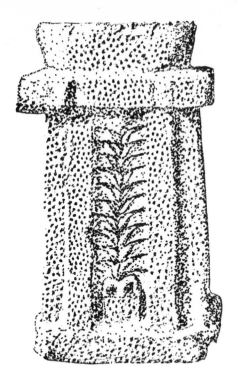

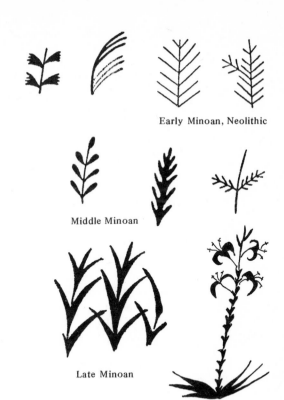

Early Minoan, Neolithic

Middle Minoan

Late Minoan

Middle Minoan

Left: Limestone pillar altar carved with 'plant in flower pot' motif on four faces. Hagar Qim.

Top right: Minoan plant motifs

Bottom right: Plant motifs from New Grange.

four panels of the 'altar'. The tub, as suggested by the reliefs, was probably made of limestone and was decorated with drilled holes. Tubs such as this were found at Tarxien. It is possible then that plants may have been symbolic of the life force, understandable in an agricultural community. Plant motifs are also found on pot sherds.

It is interesting at this stage to recall the pillar altars with plant motifs depicted on some Mycenaean and Minoan objects, although it must be noted that the date of the Maltese carvings pre-date the Minoan and Mycenaean motifs by up to a thousand years.

It is possible that a plant or tree cult developed in Malta, and was the forerunner of the cult which was to be so popular at a later date in Mycenae and Crete. One must also note the appearance of what may be a similar plant motif carved on stone 2, of the passage grave of Pierres Plates in Brittany, and of a branch carved on a stone at New Grange, in Ireland. Apart from the influ-

ence of the plant cult, other ideas were also expressed in curvilinear designs.

Reference to the excavation reports and to the naturalistic reliefs at Tarxien [53,57], will show that rams and goats were sacrificed, and that the bull and perhaps the cow was a symbol of fertility [68, 69, 70]. All have horns. The 'horns' on the spirals may also represent these.

The fact that Malta is an island, suggests that the sea also played an important part in the everyday life of the people, and may also have had some bearing on their religious philosophies. The spirals with their 'horns' may also have suggested the waves with their crests, much like the spiral and crest motif seen on some Minoan pottery. The fish with its tail and fin [3 and 4] depicted naturalistically at Bugibba may also have been symbolically suggested by the 'horns' and 'tails'.

In short, it is possible that a religious art developed on the islands as a language capable of conveying various complex religious ideas and associations in a single form.

This is further suggested by the use of spirals arranged as oculi, on stones at Ggantija, Hagar Qim, Bugibba and Tarxien. It seems possible that here we have the spiral used for a different purpose, that of representing the eyes of the goddess, while at the same time also conveying all the other religious ideas for which the spiral and its derivatives stood.

The oculi blocks [12,21] are interesting as they appear to have blocked access to certain parts and chambers of the buildings. There appears to have been many more than are now known [71, 72, 73, etc]. The 'V' wedges seen on these blocks apart from being an artistic device, probably represent the nose and brow of

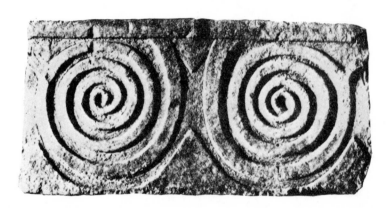

Blocking stone (21) with oculus spirals at Tarxien, Middle Temple.

the goddess, in a development similar to the Iberian schist and plaque goddess.

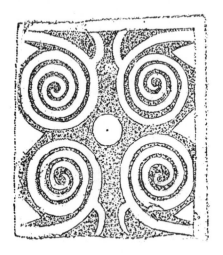

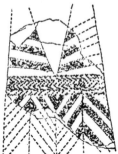

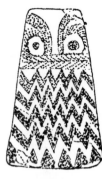

Left: Iberian plaque goddess, showing the stylization of the face to simple lines separated by a wedge.

Left: Screen from Tarxien (22) with relief of double oculus spirals, with 'horns' like 'brows', and 'V' wedges, which on block **23** are horizontal.

Most interesting are the two screens decorated with double oculus spirals [**22, 23**]. Here some effort seems to have been made to arrange four eyes in a way that whichever way one approached, vertically, horizontally or even sideways, the eyes of the goddess would confront one. The presence of the disc in the centre of the screen and the long 'horns' also suggest other religious significance. Zammit has suggested that these screens may have been painted. A fragment of relief carving with painted ground was found at Ggantija [**10**]. The disc seems to have been used in other ways than on the screens as is suggested by **67**.

PMTT p. 29.

The background on some blocks has been covered with drilled holes. This has been suggested by some authors to indicate greater antiquity than those without. It is, however, difficult to support this view, as mentioned elsewhere in the book, drilled holes are found in most buildings and often decorate otherwise uncarved blocks. At Ggantija in the South Temple, which is taken to be the older of the two, drilled holes occur with decorated blocks, while in the later building, only blocks with drilled holes occur. In fact, blocks carved with drilled holes and motifs in relief occur at Ggantija [**6**, see **11**], Hagar Qim [**12, 13**], Tarxien, middle 'temple' [**22, 23**] and loose [**67, 73**] and Tas Silg [**74**]. They also occur on the side and backs of some of the decorated panels [**32, 40**]. It

is possible that in some cases the drilled holes may have served as a key for plaster, which was then painted.

It is difficult to suggest a chronological arrangement for the motifs, but the following hypothesis is put forward. The earlier spirals appear to have been plain, probably tight. Later developments were looser and embellished first with single 'horns', double 'horns', double 'horns' and 'tails', double 'tails' and double 'horns'. The 'C' seems to have developed alongside the spiral, becoming elaborated by elongations until it formed motifs similar to **51, 52, 64, 65**. Some of the curvilinear designs can also be seen on the pottery, mainly Ggantija, Saflieni, and Tarxien.

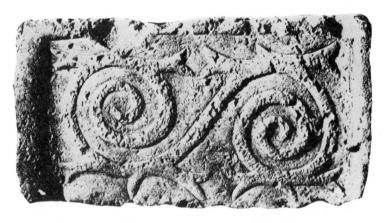

Relief carving from Tarxien **(40)** showing developed 'S' spiral with 'horns' and 'tails'.

The reliefs in the Middle Temple of Tarxien have been taken to be older than those of the Third Temple (west). Zammit argued this on stylistic grounds. On the basis of stylistic typology described above this does not seem to be the case. The design of the screens **22** and **23** are highly developed with 'horns', and arranged in a complicated fashion. The blocking stone **21** also has 'horns'. They would seem, therefore, to have been produced rather later, probably after many of the carvings in the Third Temple, though as mentioned earlier, all dating is relative, no time scale can be attached.

Naturalistic motifs are found at six sites, Bugibba, Ggantija, Hagar Qim, Mnajdra, Tarxien, and Hal Saflieni. With the possible exception of the 'painted bull' [**14**] and the 'hand' [**17**] from Hal Saflieni, all are contemporary with the curvilinear motifs and must be examined as a separate branch of the megalithic art. They are, however, of widely differing natures. One group, Tarxien [**53** and **57**] represents victims for sacrifice. Charred bones and horns have

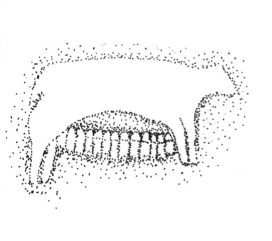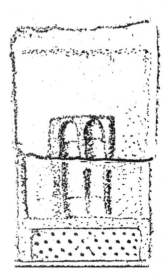

Naturalistic relief carving at Tarxien showing the so called 'sow with piglets.' On close examination the 'piglets' look more like the so-called phallic symbols seen on the right, all found at Tarxien.

been found in the excavations. Another group of bulls and a cow? also at Tarxien appear to be fertility symbols. These animals are cut on two orthostats housed in a small room between the Third and Middle Temples. Two are obviously bulls [70 and 68], but the third [69] is of interest as it has been suggested that it is a sow suckling thirteen piglets. On close examination there is little to support this theory, the piglets look little more than cylinders, very similar to the so-called phallic symbols also found at Tarxien, and the anatomy of the animal looks more bovine than suidian. With horns there would be no doubt at all that the figure represented was a cow, but that vital area is much worn. Even Zammit stated that 'the animal's head is not clearly defined owing to the flaking of the stone'. There can be no doubt that the sculptors when producing naturalistic reliefs were well able to depict the anatomy of various species (especially the pig) quite accurately [see57]. To the writer it would seem on the evidence available that the animal represented is the cow. The symbolism suggested earlier is fertility and the phallic symbols shown under the cow would, therefore, be perfectly in keeping with 68 and 70. Further discussion is given in the description of motifs of Tarxien. Bovine representations on pottery must also be called to mind especially the lid from the Hypogeum which is decorated with bulls.

Ev.M pl. 75, see also PMTT pl. XXX, 2.

Although there is a so-called outline of a bull at Hal Saflieni [14], in the writer's opinion this is not contemporary with the other megalithic motifs, and may be considerably later. The 'hand' at Hal Saflieni [17] may be put down to an illusion of lighting, and although included in the book, should not be considered with the other motifs.

Of the other naturalistic motifs, the snake/eel on a block from Ggantija [5] may be grouped with the relief carvings of a fish from Bugibba [3 and 4]. The Ggantija carving is too worn to identify with certainty. The block from Bugibba is most unusual, as it is decorated on two consecutive sides with relief carvings of fish. The treatment is highly stylised and two fish are shown face to face as if they are kissing. It is difficult to suggest a suitable interpretation for this motif, except that as suggested earlier, it expresses religious philosophies inspired by the sea. It is interesting to note the Bugibba is the nearest of all temples to the sea. Another instance of the importance of fish in ritual may be seen in the unusual model of a fish on a couch found in the Hypogeum of Hal Saflieni. The outline of a fish is modelled on to a bed, of the type used for the figure of the 'Sleeping Lady of Saflieni'. There is another representation of a fish found in the Hypogeum, but it is of clay. If the Ggantija relief [5] is of an eel it would be in keeping with these.

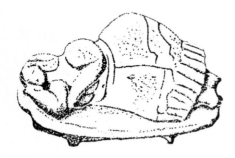

Carving of a fish on a bed found in the Hypogeum of Hal Saflieni, similar idea to the Sleeping Lady of Saflieni.

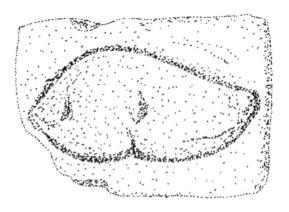

Limestone fragment engraved with a design of radial lines and stars, found at Tal Qadi.

The significance of the plant motif at Hagar Qim has been suggested earlier. Lower down on the cliff from Hagar Qim at Mnajdra, there is an outline of a megalithic structure carved on an orthostat. It probably served as an architect's drawing, as no other suitable interpretation can be suggested.

The reliefs in category 3, abstract, and motifs other than in categories 1 and 2, include three abstract representations from Tarxien, three panels with graffiti of ships, also from Tarxien, and a fragment of limestone with an engraving of radial lines and stars from Tal Qadi. The head of a statue-menhir from Zebbug has been mentioned earlier.

The abstract blocks from Tarxien are unique. One has a motif of an irregular shape with projections shooting off upwards and downwards [32]. Although it could be suggested that the projections represent 'horns' it is more probable that the relief is intended to represent seaweed, and in that case is almost naturalistic. The smaller block which stood in front [33] is more geometric, but may represent the same theme. Similar designs are found on the pottery. The third relief [31], which is on a panel on the base of a statue of the mother goddess, is more difficult to interpret. The design is formed from ovoids, separated by 'double axes' or concave and convex lines. It is not suggested that the 'double axes' are indeed such, but only that they resemble them in shape.

PMTT fig. 29, 32, 33.
S pl. 18.

Graffiti of ships on two orthostats at Tarxien [48, 49, 50] were recognised by Diana Woolner and published by her in 1952 in *Antiquity*. These are included out of interest. Their condition seems to have deteriorated since they were described by Woolner, as a number of 'ships' seen by her can no longer be discerned. Although she suggests that they are contemporary with the 'temples', the present writer find this difficult to accept. They are not in keeping with the theme or quality of the other motifs, and

if suggested as a sort of 'Kilroy was here', one has to remember that they adorn part of a sacred structure, and such a profane act would have been almost unthinkable. However, there would be no such drawback if they were made after the 'temple' was in ruins.

The stone with stars and radial lines from Tal Qadi [20] is both unique and interesting. Stars of varying numbers are engraved in five segments. Unfortunately, it is only a fragment and the writer can only suggest that it was intended for some ritual purpose (with apologies for including this much hackneyed term) or that it was some kind of astronomical chart. Are the crossed lines really stars? Are they Suns? Like other designs inspired from nature they might represent flowers. Without other examples of this kind of motif it is unlikely that we shall ever know. Both motif and technique are different from those employed on other stones.

Apart from the carvings and paintings mentioned above, there are orthostats which have an area carved to a lower level, with an arched top. These are carved on all four faces. An example is illustrated in *Evans' 'Malta' plate 23*. The Brocktorff drawings also show that similar orthostats were present at Ggantija.

It is at Tarxien that we can perhaps best appreciate the art, for here a number of blocks of various shapes were decorated. Generally, but with some exceptions, orthostats were not carved, though a number have been decorated with drilled holes, especially at Mnajdra. Blocks with carved faces appear to fall into groups: (1) Blocking stones, used to block access to various chambers to areas; these are decorated with oculi. (2) Screens, decorated with double oculus spirals; they appear to have had a similar function to the blocking stones and although only two of these are intact there may have been others. (3) 'Altars', these are large quadrilateral blocks, carved on more than one side. One at Tarxien [25] was hollowed out after it was carved and a number of charred bones and a flint knife were discovered in the interior. (4) Transept stones, a term used to describe a series of blocks, some square others oblong, that would probably have fitted together in a semi-circle round the walls of a transept in the order of one square, one oblong, etc. The remains of such an arrangement still exist in the terminal chamber of the Third Temple at Tarxien, although here the blocks are undecorated, but have carved relief borders. The majority of the carved transept stones were found in the first transept (west) of the Third Temple and it

is possible that such an arrangement included the two orthostats with carved arches mentioned earlier. A study of the measurements of the various blocks lends further weight to this suggestion. (5) Oblong blocks with stepped blocks on top, carved out of a single stone. The arrangement of the top blocks is similar to that suggested for the 'transept stones'. (6) Large horizontal carved blocks, these seem to have been used to separate areas of higher elevation from areas of a lower elevation. At Tarxien, one is across the entrance to the terminal chamber of the 'Third Temple'[66] which is at a higher level. Although this is the only example carved in relief, there is a similar stone at Ggantija South, in several sections, which block the area in front of the

The terminal chamber of the third temple at Tarxien, showing the long relief panel **66** with a design of conjoined vertical 'S' spirals.

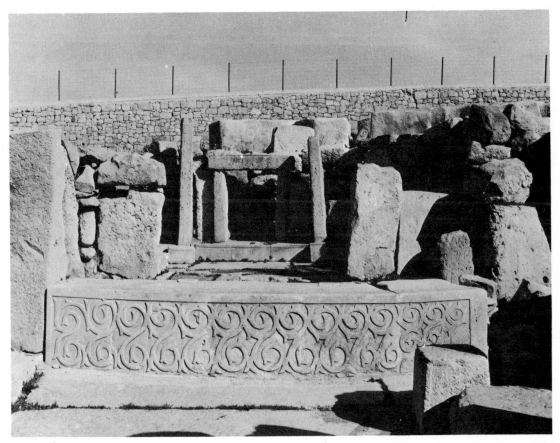

terminal chamber. In this case it is decorated with drilled holes. In addition to the above there are the carvings on the miscellaneous objects mentioned earlier.

The overall appearance of the reliefs is one of sophistication and quality, and it is hard to realise that they decorate the interior of buildings constructed between 2700 B.C. and 2300 B.C. It is only when we see the components of the relief carvings expressed as paintings in the Hypogeum, that the impression of antiquity returns. The very nature of the stone of the island is partly responsible for the quality of the appearance of both the buildings and the carvings. The Globigerina limestone is soft and easy to work and was chosen by the early builders for cutting into fine faced blocks for the interiors, while the exteriors were on the whole constructed from the harder Coralline limestone which has a tendency to split into natural megalithic slabs. With such an easily worked medium, the early megalithic builders were able to obtain a far greater quality in their lithic work than their W. European counterparts, who had to contend with much harder stone, with all the inherent difficulties of carving with stone tools. No such difficulty confronted the Maltese artisan, he was able to work the limestone with ease, allowing his creative imagination full licence. The precision of the carving of these blocks, worked with only simple stone tools is amazing.

The design for each block was conceived as a composition in the artisan's mind before he started work. It was usually well balanced and utilised all available space. This practice can be seen clearly in the blocks of uneven shape or which have some parts damaged and yet which the design has been specially arranged to fit. It can be deduced from these examples and from the fact that areas of some blocks that were covered by other blocks, leave the hidden area undecorated in the precise shape of the carving blank, that the stones were carved in situ. A practice also carried out at New Grange in Ireland, as revealed by Professor M.J. O'Kelly's recent excavations on that site. It is probable that the blocks were carved over a period, the motifs on each panel progressing from one to the other, much as an artist modifies his ideas as he progresses from one painting to another. Therefore, a development on one panel may be reproduced on another or even further developed. It is impossible to determine how many hands were responsible for the carvings.

The drilled holes are more difficult to understand. As stated elsewhere they decorate a number of blocks, but several at Tarxien have drilled holes on faces that would not have been seen [32, 39, 40, 66]. These suggest that either the faces had some special significance and were not intended to be seen (again similar to Professor M.J. O'Kelly's discoveries at New Grange) or that they were not in their original positions. Another possibility is that they were re-used, and that the face with the drill marks hidden, while another face was carved, in some cases the blocks may have been completely turned around [32].

In making comparisons with the megalithic art of Western Europe and that of the Mediterranean, a number of factors must be borne in mind, both chronological and geographical. The carvings although highly sophisticated in appearance are, in fact, extremely early, being produced mainly between 2400-2300 B.C. This is only approximate, based on the dates of the buildings in which they are housed.

Several attempts have been made in the past to associate the motifs with those of Mycenae, but the date of the 'temples' as understood then was much closer to the Mycenaean than it is now, therefore, the comparisons are no longer valid, and are only of interest as an exercise in comparative artistic development.

The Maltese spiral and the Mycenaean are, in fact, very different. All spirals in Malta without exception are single spirals, i.e., they run towards the nucleus and then stop. Although joined together in rows of 'C' or 'S' spirals, they are all separate spirals that have been placed adjacent to each other, and sometimes joined with such devices as the vertical 'tail', etc. The majority of the spirals of Mycenae, both on small objects and reliefs, including the stele over shaft grave V, grave circle A, at Mycenae, which has often been used for comparison are continuous running spirals, in that they run towards the nucleus and then outwards eventually forming another spiral, running towards the nucleus and out again, etc.; in reality a double spiral. A perfect illusion of a continuous spiral is given by the ingenious motive 42, which is in reality vertical oculus spirals within separate cells.

See My pl. 20 or AE Pl. XV.

Spirals from Minoan pottery.

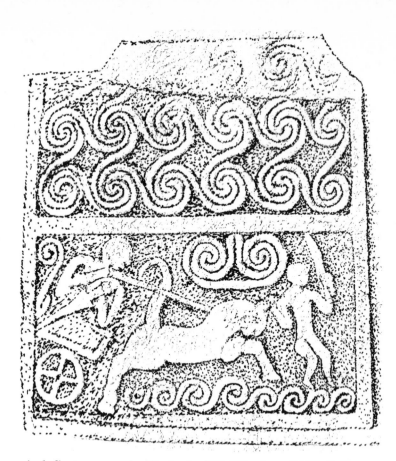

Spirals on the stele from shaft grave V at Mycenae.

The spiral first occurs in Crete in EM III circa 1800 B.C. on Kamares pottery. The pottery is decorated with a number of spiral designs including the wave and crest motif, the continuous spiral and the 'S' spiral. Spirals continued to be developed and used on Minoan pottery and also on Mycenaean. The expression of a plant as spirals, is seen on an amphora with designs of papyrus, c. 1450 B.C.

The similarity between some of the motifs of Crete and Malta may perhaps best be explained as parallel developments inspired by similar stimuli circumstances. Both are islands with similar flora, drawing their religious ideas from the land with its plant life and from the sea. Whether one was the model for the other is impossible to determine. The chronological difference is very great.

The comparison with motifs near to Malta is more profitable although they are still not chronologically compatible. The spiral reliefs on the blocking stones of the tombs at Castelluccio in Sicily recall the oculi blocks and the screens at Tarxien, but as Brea points out the Maltese reliefs are both artistically superior and chronologically earlier.

S pl. 33.

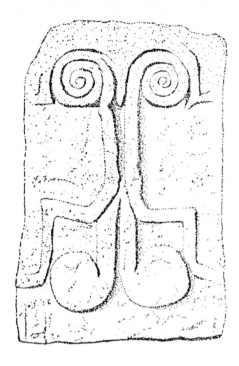

Double spirals on the blocking stone at Castelluccio in Sicily.

In Sardinia the importance of the bull as a fertility symbol was expressed in relief carvings, such as the symbolic horns and bull's head which decorate the Copper Age tombs at the Anghelu Ruju cemetery, also Sedini, Sennori, Calancoi and Castelsardo del 'Elefante . Some of the carvings represent the bull's head almost naturalistically while others are stylisations concentrating on the shape of the horns. Sometimes they were painted with red ochre.

A tomb at Pimental has a facade with carvings of double spirals running clockwise and anti-clockwise on stems as well as joined horizontally. The carvings which are emphasised in red are almost like oculi, but maybe a development of the horn motif. They also recall the spirals at Castelluccio. The Sardinian comparisons like the Sicilian appear to be later than the Maltese.

Comparisons with the motifs which decorate the megalithic tombs of Ireland, France and Iberia, are made difficult, by the superficial differences in appearance, differences mainly due to medium. As stated before, the Maltese limestone is extremely soft and, therefore, can be worked with great precision with only simple stone tools. On the other hand, the stone used for the megalithic tombs of Europe is hard by comparison and had to be

worked by a different method, mainly by dressing with stone mauls and pecking, although incision was sometimes used. Although the dissimilarity of the reliefs is very great this is not the case when the motifs are expressed as paintings as in the Hypogeum. If we make allowances for the varying appearance of the carvings and place them on a common footing, the real differences between the art will become apparent.

With the exception of certain stones at New Grange and Knowth in Ireland, the art of the megalithic tombs is symbolic magico-religious, with little decorative form or quality, while the Maltese, although having strong religious symbolism, is also highly decorative. The comparison is almost that of child art with that of an accomplished artist.

The Maltese motifs are, as has been stated, mainly curvilinear based on the spiral, a design not common in Brittany, and comparisons with the majority of the motifs of that region prove negative. The possible exception being the plant motif on a stone at Pierres-Plates, Locmariaquer and also the spirals at Gavrinis.

B pl. 30; CSGMMM pls. 119, 120, 124, 130.

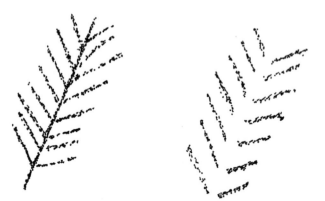

Plant motifs from Irish Passage Graves.

Chronologically the megalithic art of Brittany may be earlier than the Maltese. We have a radiocarbon date of 3030 ± 75 B.C. for the Passage Grave of Ile-Carn, Ploudalmezeau (Finisterè) and the Passage Grave in the Sept-Iles archipelago, off Perros-Guirec in the Côtes-du-Nord has given radiocarbon dates of 3450 ± 135 B.C. 3215 ± 130 B.C., 3055 ± 150 B.C. However, the Passage Grave of Mané-Kernaplaye, Saint-Philibert, Morbihan, has given much later radiocarbon dates of 2785 ± 120 B.C. and 2470 ± 120 B.C.

It is almost as difficult to make convincing comparisons with the motifs of the megalithic art of Ireland. However, the plant motif can be paralleled at New Grange, at Knowth and Loughcrew (Breuil's 'fir-tree' motifs) and the spiral, the most common motif in Malta, is also a characteristic of Irish Passage Grave art. It can be seen in a number of forms, single spirals, double spirals conjoined running in the same direction towards each nucleus, triple spirals, horizontal tight 'S' spirals separated by lozenges. Many of these spirals are continuous, i.e., they run towards the nucleus and then out again. In this respect they are more similar to the Mycenaean than to the Maltese. Possibly the most impressive spiral combinations are the triple spirals found at New Grange, especially on the fine kerbstone. The double spiral is found at Loughcrew and

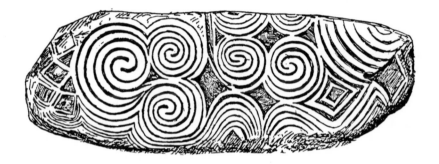

The triple spirals on the kerbstone at New Grange, Ireland.

New Grange, while the single spiral is common to a number of tombs of the Boyne culture. A remarkable single stone decorated with spirals was found at Clear Island, County Cork. The centre spiral is continuous and similar to some at New Grange.

Outside Ireland the spiral is only found in isolated circumstances. In Brittany it appears at the Passage Grave, Gavrinis. Although a spiral is incorporated into the design on a slab from Monte de Eiro, Marco de Canaveses, Portugal, it is not found in any Iberian megalithic tomb. A few painted spirals are known (five) in Andalusia, and some spiral rock carvings are known at Monte-de-Saia. In spite of these examples the spiral appears as an alien element in Iberian megalithic art.

The spiral is more common in the British Isles. Its appearance in some of the tombs of the Boyne Group in Ireland has already been mentioned. In Wales at Barclodiad y Gawres, there are several examples, with another nearby on the Pattern Stone at Bryn Celli Ddu. In England at Calderstones, Liverpool, several examples of

McW 1946.

MASMS, 150, fig. 40.
McW 1946 p. 65.

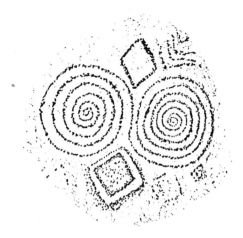

Oculus spirals on a stone at New Grange. A similar design was found on a pot sherd at Skara Brae in the Orkneys.

spirals have been found, one an 'S' spiral. In addition to the above a potsherd with spirals as oculi, separated by lozenges, recalling the blocking stones of Malta, has been found at Skara Brae in the Orkneys. The chalk drums with their spirals as oculi, from Folkton in the E.R. of Yorkshire, are also recalled.

The spirals of New Grange have been compared by some writers with those of Mycenae. With radiocarbon dates suggesting a date of 2500 B.C. for New Grange, we can see that this comparison is now unlikely. It is closer chronologically with the megalithic structures of Malta but as has been shown above the spiral in many cases is dissimilar in structure and it would perhaps be unwise to note anything more than a chronological parallel.

The 'stars' on the stone from Tal Qadi, could be paralleled with similar 'stars' at Loughcrew and also at Dowth in Ireland. The discs at Hal Saflieni and on the screens at Tarxien may perhaps be compared with the single circles at Dowth, Knowth, Loughcrew and New Grange. Concentric circles are, however, not found in Malta at all.

NCBI pl. XII, 4.

PA 107.

'Stars' and discs from Loughcrew, Knowth, Dowth and New Grange.

Probably more important than the positive comparisons are the negative comparisons. Concentric circles, lozenges, zigzags, concentric arcs, etc., while present in Ireland, Brittany and Iberia, are notable by their total absence in Malta.

Although the motifs of Brittany, Ireland and Iberia, have a symbolism which is basically similar, each has developed in its own way making the motifs difficult to compare.

Possibly the only convincing explanation for all these divergent features of the megalithic art of all these regions including Malta, lies in a common religious philosophy, collective burial, and all the magico-religious rites associated with it. These basic ideas were expressed not only in the buildings but also in the art, each developing in semi-isolation, allowing environment and social circumstances to play their part. The result being the overall similarity and yet individual dissimilarity.

In conclusion, at the present stage of our knowledge, and until further radiocarbon dates are available, it is not possible to see any more than common religious philosophy as a source of inspiration responsible for the great megalithic art of both W. Europe and the Mediterranean.

Replica of block **42** at Tarxien. This block is carved with one of the most unusual and complicated spiral compositions in the whole repertoire of Maltese megalithic art.

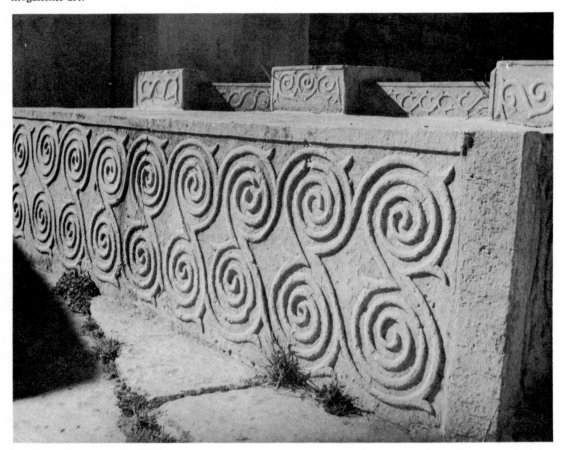

BUGIBBA

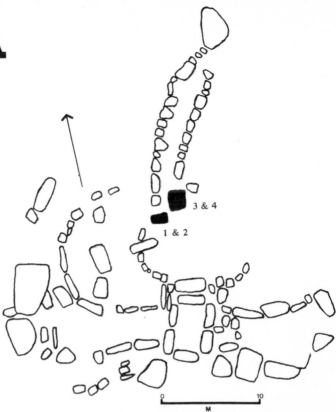

Plan of Bugibba showing positions of carved blocks.

General view of Bugibba showing the collapsed trilithon entrance.

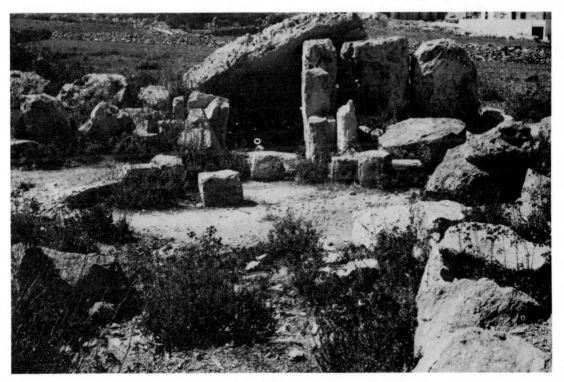

Situated on the south-eastern side of St. Paul's Bay, on the N.E. coast of Malta, this building is badly damaged, but sufficient remains to indicate that it was a single unit of the trefoil type. Excavation suggest that it dates to the LN III phase.

Two carved blocks were found in the ruins, at the northern end of the building. Although adjacent to each other they may not have been in their original positions. They are now in the National Museum, Valletta. The 'temple' has since been tidied up and is now incorporated into the grounds of the Dolmen Hotel.

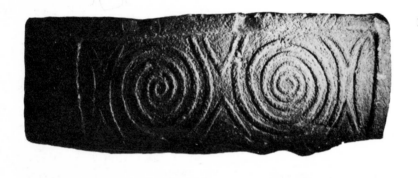

1

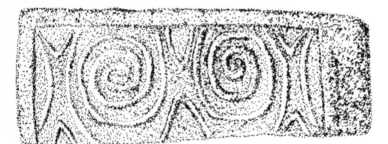

2

1-2. Bugibba. Limestone block with two panels carved in relief. **1.** 98 cm. x 33 cm. approx. **2.** 91 cm. x 32 cm. approx. National Museum, Valletta.

The block is carved in relief with two consecutive panels, 1-2.

1. Double tight spirals as oculi, separated in the centre by vertical and inverted 'V' wedges, and at each end vertical and inverted wedges between concave and convex lines. The complete motif within relief borders.

2. As 1, but worn.

The far left on panel 1 and the far right on panel 2, has been left rough suggesting that when in its original position, other blocks were placed behind and at each end. The motif of 1 and 2 can be compared with Ggantija 6, Hagar Qim 12, and Tarxien 21.

Ev.M. p. 124

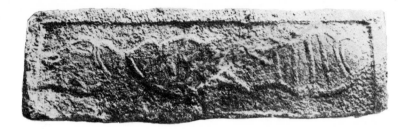

3

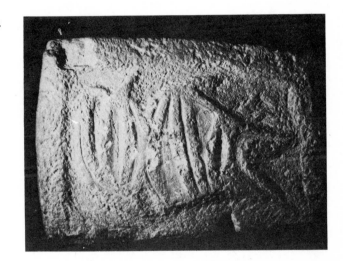

4

3-4. **Bugibba.** North end of building. Limestone block carved in relief on two faces. **3.** 92 cm. x 28 cm. approx. **4.** 38 cm. x 28 cm. approx. National Museum, Valletta.

The block is carved in relief on two consecutive sides.
3. Two highly stylised fishes are shown apparently kissing. Although the species is not apparent, the scale pattern is clearly depicted. To the right is a large fish with spines and stripes facing the right edge of the panel. There is some wear and damage.
4. This panel is not as wide as 3. A fish faces the large fish on panel 3, but is badly carved and gives the appearance that the sculptor ran out of space and crowded the face area, making it difficult to recognise.
Both panel 3 and 4 are within relief borders, but now worn on the vertical edges.

PRMI pl. x, p. 77
Ev.PPS/53 p. 61

GGANTIJA

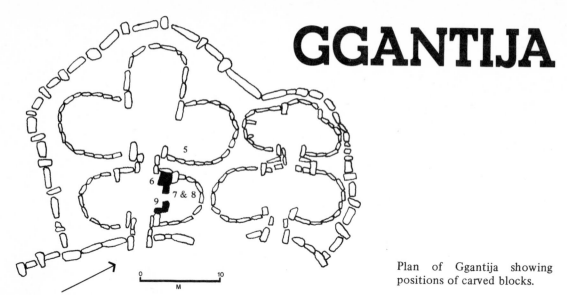

Plan of Ggantija showing positions of carved blocks.

The ruins of Ggantija at Xaghra on the island of Gozo, are by far the best preserved of the megalithic buildings of the Maltese islands. They consist of two 'temples' of the transepted passage type, two sets of transepts leading off a central passage, which terminates in a semi-circular chamber. The 'temples' are formed into a composite building by a common outer wall.

The material used for the outer wall of the building is Globigerina limestone which was quarried some distance away from the site, as no such stone exists in the area.

Excavations at Ggantija were begun in 1827. We have a number of drawings by Brocktorff, made in 1829 which show the ruins. They are important, as they show stones and details which have since disappeared or been destroyed. Stones carved with spirals and drilled holes have completely worn away, due to exposure to the elements, and it is now difficult to reproduce these with accuracy. The reader is referred to the tracings of parts of two drawings by Brocktorff, plate ll, however it should be pointed out that these only convey an impression of the motifs. Examination of the motifs still visible in situ suggest that they were formed differently to the way Brocktorff shows them. They are similar to some at Tarxien [25, 44, 46 and 66].

Some fragments of plaster have survived in position indicating that the interior of the Ggantija 'temples,' at least, seems to have been plastered and painted. Several fragments in the museum are painted with red pigment. A small fragment of a large spiral carving with the surface painted red between the relief was recovered from the area and is now in the Gozo Museum [10]. Red painted spirals can still be seen in the Hypogeum at Hal Saflieni, on Malta.

All but one of the carved blocks were unearthed in the right outer transept of the Southern Temple, while the representation of the snake/eel [5] came from the right inner transept of the same building. Apart from the blocks carved with relief motifs, a number of blocks were decorated with drilled holes, some within carved relief borders. These were found in both buildings.

Report of the Museum Dept. 1966. p. 8. Malta 1968

Interior of the Ggantija temple.

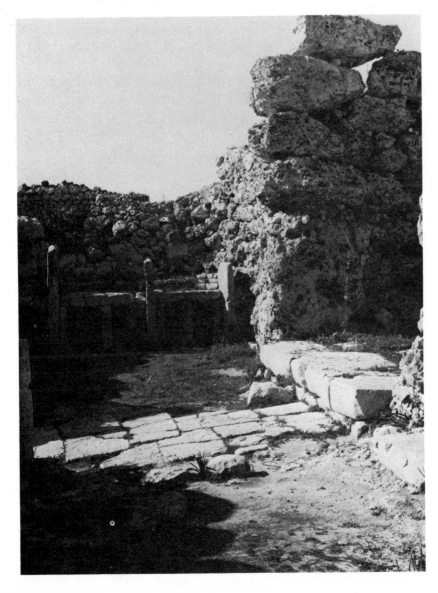

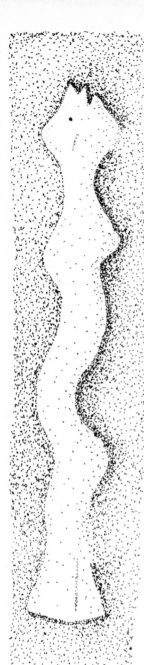

5 Ggantija. Southern 'temple,' northern inner transept. Large vertical limestone block with vertical edge panel carved in relief.. 184 cm. x 27 cm. Gozo Museum, Victoria, Gozo.

Orthostat with edge carved with the representation of a snake or eel in relief. The head is worn, and the shape may be accidental due to wear and chips, but it is basically accurate. The 'eye' appears to be drilled. There is a slight groove near the tail, which could be a splayed fin. The edge appears to have been formed by drilled holes, now eroded, and the lower part of the stone is not faced but has been left rough. The length of the snake/eel is 107 cm.

The description of this block is made as it is now, standing in the Gozo Museum, although when in situ it may have been horizontal.

Ev.M. p. 151
Ug. fig. 43
VDM fig. 4
Ev.PPS/53 pl. 61

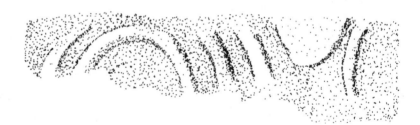

6 Ggantija. Southern 'temple,' northern outer transept. Horizontal block facing entrance, originally with motifs on two consecutive sides. 107 cm. x 40 cm. approx. In situ.

This block is now highly eroded and little remains to suggest its original appearance. However, panel **6** appears to be similar to the blocks with the oculus motif seen at Bugibba [1 and 2], and Tarxien [21]. Study of the Brocktorff drawings [11], will give a better impression of the original appearance of the block. The side was similar to **6**, but was vertical. The arrangement of transpositions was similar to the large screens at Tarxien [22 and 23]. The background of the block seems to have been decorated with drilled holes.

Ev.M. pl. 7, p. 99

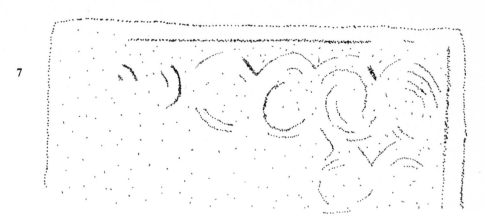

7

8

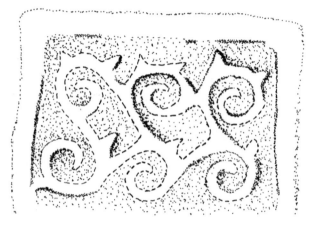

7-8 **Ggantija.** Southern 'temple,' northern outer transept. Limestone block with two consecutive sides carved in relief. 7. 112 cm. x 40 cm. approx. 8. 53 cm. x 40 cm. approx. In situ.

This block, like the others in the building, is weathered, and the motifs on the two panels are difficult to discern. Panel 7 faces the passage, while panel 8 faces the entrance.

7. Badly weathered, the motif is difficult to trace, but appears to be similar to Tarxien 42. Two rows of tight spirals are superimposed and joined both vertically and horizontally. Due to wear it is not possible to tell whether 'horns' were present. The motif was within a relief border.

8. Very badly worn. The drawing shows both the original grooves still discernible and a possible reconstruction. The motif appears to have a combination of vertical 'S' spirals with 'horns,' joined in a manner similar to running 'C's,' the whole within a relief border. Reference to Brocktorff drawings [11] suggests that Brocktorff's observation was not entirely accurate, either accidentally or perhaps due to the possibility that the panels were already worn when he drew them. The motif is similar to **25, 44, 46** and **66** of Tarxien.

Ev.M. pl. 7, p. 99

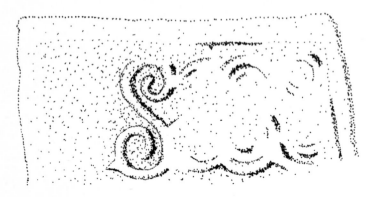

9 Ggantija. Southern 'temple,' northern outer transept. Limestone block, originally with two panels carved in relief. 34 cm. x 65 cm. approx. In situ.

Ev.M. pl. 7, p. 99

This block is similar to the block with panels **7** and **8**, although in a worse condition, making it only possible to record one face, that facing **8**. The longer face has now disappeared, but may have been similar to **7** [see **11**]. The motif on panel **9** appears to have been formed by a combination of vertical 'S' spirals with 'horns,' joined in a manner similar to running 'C's,' within a relief border. The motif appears to be greatly similar to **8**. Part of the left-hand side of the panel is rough.

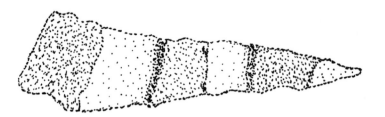

10 Ggantija. From area near temples. Fragment of a limestone block carved in relief with spirals and with red painted ground. 22 cm. x 5 cm. approx. Gozo Museum, Victoria, Gozo.

Small fragment of a carved limestone block, with relief spirals, showing the ground painted red. This piece lends support to the supposition that the interior of Ggantija, if not elsewhere, was decorated with paintings in red. It was probably originally part of a large screen or blocking stone with double oculus spirals.

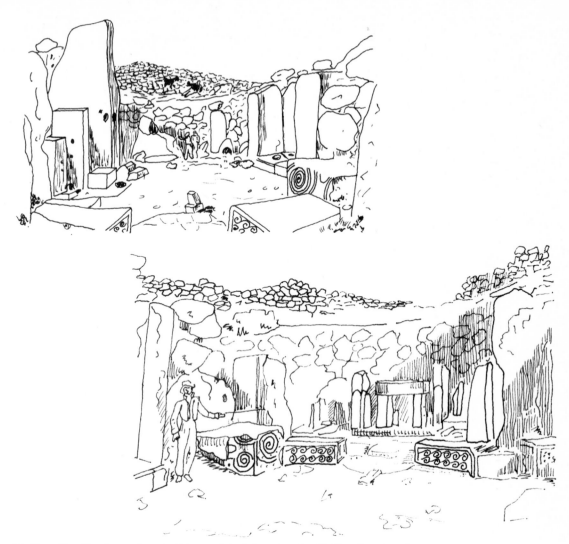

11 Ggantija. Tracings of part of two original drawings by H. Von Brocktorff, c. 1830. National Museum, Valletta.

Parts of two original drawings by Brocktorff have been reproduced to aid study of the motifs at Ggantija, showing them as the artist saw them when they were first excavated.

Although probably not entirely accurate, they convey the artist's impression. On the whole, Brocktorff was an accurate observer and all measurements and colourings are recorded on the drawings. Altogether 15 drawings, pen and ink over pencil sketches of Ggantija, are in the National Museum, Valletta; they were acquired in 1966. One is dated 1829, and three are marked "done for His Grace the Duke of Buckingham." One of those reproduced in plate **11**, is the original sketch for a painting which is illustrated in Evans' 'Malta' 1959, plate **7**.

Report of the Museum Dept. 1966. p. 8. Malta 1968
Ev.M. pl. 7

HAGAR QIM

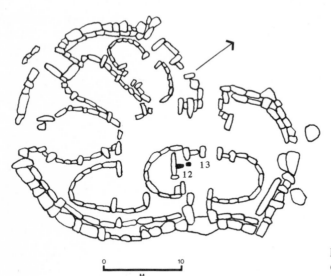

Plan of Hagar Qim showing positions of carved blocks.

The 'temple' is situated on the west coast of Malta, opposite the island of Filfla, and near the village of Qrendi. Dating from the LN I phase, it is a most complex building, incorporating three transepted structures, altered at various times, in a single outer wall. The orthostats in the outer wall are among the largest and most impressive in all the Maltese structures.

Unfortunately, as with most of the Maltese megalithic structures, it was badly excavated early in the 19th century. Excavations were first conducted by J. G. Vance in 1839, Caruana carried out further work in 1885. In 1909 further soundings were made by Zammit and Peet and in 1910 by Ashby. Recently excavations were made in all parts of the building (1954).

Only two examples of megalithic art have been recovered from the site, although there may have been more. One is a small blocking stone carved in relief with loose oculus spirals, with a background of drilled holes [12]; this was found facing the entrance on the left of the passage near the left transept. Nearby, to the right, was a most unusual pillar 'altar' [13] with the lower parts, divided into four panels, in each of which is a carving of what appears to be a plant growing out of a pot. The surround and background is covered with drilled holes. As all the panels are similar, only one has been reproduced here. Apart from these two motifs, there are a number of other blocks decorated with drilled holes.

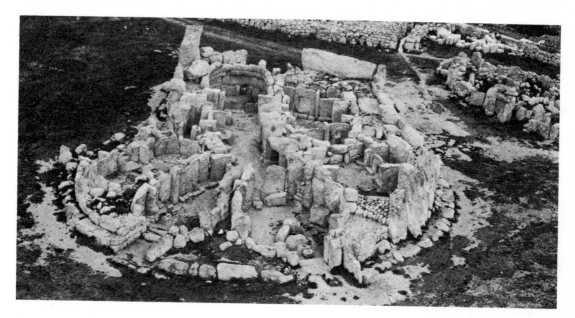

General aerial view of Hagar Qim.

This small blocking stone is carved with oculus spirals divided by a rounded 'V' shaped wedge suspended from a horizontal relief border. The background is filled with drilled holes. A smaller version of **21**, it appears to fulfil the same function. Unlike **21**, however, it does not have 'horns' and has a background of drilled holes, while **21** does not. It is also comparable with **1** and **2** of Bugibba.

Ev.M. pl. 78, p. 108

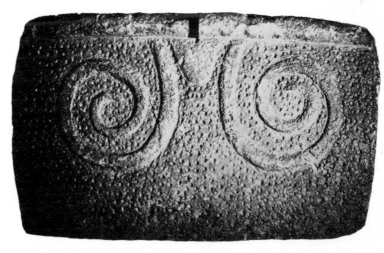

12 Hagar Qim. Main passage, outer transepts. Limestone blocking slab with panel carved in relief with oculus spirals. 72 cm. x 43 cm. National Museum, Valletta.

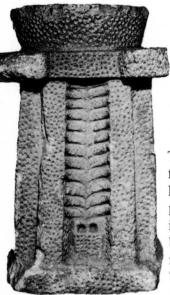

13 Hagar Qim. Main passage, outer transepts, facing entrance. Pillar altar carved on four faces with motifs in relief. Approx. panel height 45 cm. National Museum, Valletta.

This most interesting motif is unique, in that it is the only purely floral naturalistic motif found in the megalithic structures in Malta. A tall symmetrical plant appears to grow out of a tub or pot, and fill the entire panel it decorates. The 'altar' itself is interesting. When viewed objectively it gives the impression of a building composed of four trilithon entrances, with the plant motif in each 'entrance.'

The presence of the plant motif is most significant. As stated elsewhere in the book, the influence of flora on the motifs is very strong. Here we have a clearly recognisable plant, but what is its significance? Why is it depicted on such an obviously important object? It is possible that the answer to these questions lies in appreciating the stimulus behind many of the motifs. The tree or plant had very strong influence on the forms expressed in the art, and it is therefore possible that there was some kind of plant or tree cult, perhaps the forerunner of the cult which was to gain such prominence at a later date in Mycenae and Crete. Indeed, the striking similarity of this pillar altar with its plant motif to those depicted on Mycenaean and Minoan objects, especially the finger rings must be noted. However, as stated above the date of the Maltese carvings pre-date the Minoan and Mycenaean by as much as 1,000 years.

The tub from which the plant grows appears to be made out of limestone with a decoration of drilled holes. Just such a tub has been discovered at Tarxien (Prehistoric Malta, The Tarxien Temples, pl. II, p. 15). It is possible that such tubs may have had a plant growing in them, and may possibly have been placed in the entrance or just outside the entrance to the 'temples.'

Finally, we must also note the appearance of what appears to be a similar plant, carved on stone 2, of the Passage Grave of Pierres Plates, Brittany, and of a branch on a stone at New Grange, Ireland.

Ev.M. pl. 79, p. 108
My. pl. 10

54

HAL SAFLIENI

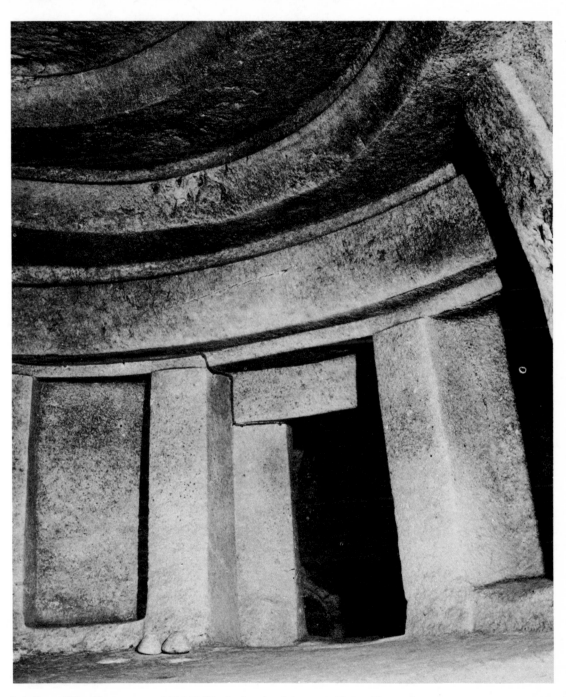

Interior of the Hypogeum of Hal Saflieni, showing false corbelled ceiling and trilithon entrance.

The Hypogeum at Hal Saflieni, near Tarxien, is a unique structure. Carved underground out of the living rock, on the top of a natural hill, it is the best preserved of all prehistoric buildings in Malta. Although not truly a megalithic structure, it must be considered together with the surface 'temples' as it preserves not only megalithic features carved in the rock, but separate megalithic trilithons and megalithic art.

Discovered in 1902, it too, however, has suffered, this time, though, due to misfortune. Father Magri, in charge of excavations, was transferred from Malta and died in 1907 before he had time to publish his notes, which have never been found. Prof. T. Zammit, continued the excavation.

The Hypogeum was probably started in the MN I – MN II phase, but the lower and more elaborate chambers date from LN I – LN III. It is a large complex of underground chambers on several levels, covering an area of approximately 1,600 square feet. It preserves many unusual features and gives the impression of a large underground cemetery or ossuary.

The best parallels are found at the Anghelu Ruju cemetery in Sardinia. One of these has an internal facade though it is smaller and simpler than the Maltese example.

The large chamber or hall of the Hypogeum, preserves all the features of the surface structures carved in the bedrock. The only megalithic paintings on the Maltese islands are found in this complex. A number of interesting motifs are preserved, painted on the ceilings, walls and lintels.

The most impressive of these is the ceiling of the chamber popularly known as the 'Oracle's Chamber.' This complex design is composed of spirals, tendrils, tails, etc., all entwined and connected. The design, which is painted in red ochre, covers the ceiling and part of the walls. In a nearby chamber, the walls and ceiling are also painted with a design in red ochre. Although connected, the design on the wall is different to that on the ceiling; the wall has an impressive honeycomb design formed of hexagons with disc and spiral centres; this joins the ceiling which is painted with a mass of entwined and connecting spirals, tendrils and 'tails.' Also in the room of the hexagons, is what has been suggested is a carving of a hand. After close examination, however, it appears to the writer to be an illusion, caused by fluke lighting conditions, falling on the uneven surface of the wall. It has however been included, see plate **17**.

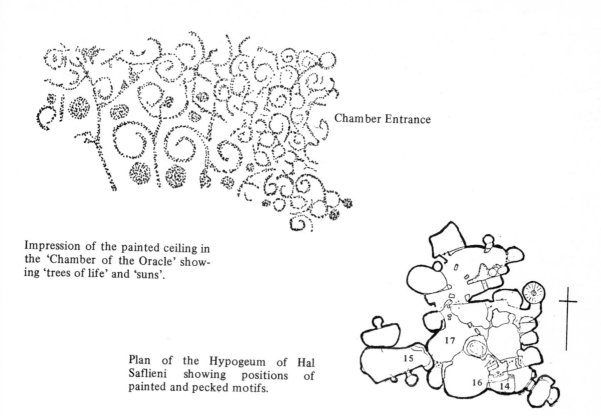

Chamber Entrance

Impression of the painted ceiling in the 'Chamber of the Oracle' showing 'trees of life' and 'suns'.

Plan of the Hypogeum of Hal Saflieni showing positions of painted and pecked motifs.

Leading off the room of the hexagons, is a small chamber known as the 'Holy of Holies.' The wall in this room was also covered with red ochre spiral designs, but these are now too worn to be recorded. Also in this room is what has been described as a painting of a bull in black [14]. After examination, however, the writer is of the opinion that this has been formed by smeared mud, after the surface of the walls had been wiped with fibre or some similar material. Whether intentional or not, it is difficult to discover; however, the original design in red ochre that covered the area had been wiped through when it was formed.

Other motifs also found in the Hypogeum include a chequered design in black and white, which covers a small area of the Great Hall, while small spirals, a solid circle and wide bands of red ochre are found in the lower chambers. Ochre is smeared over a number of areas. In addition to the painted ceiling in the 'Chamber of the Oracle,' there are three painted discs in the so-called 'Oracle Hole,' and several painted discs on the ceiling of the chamber between the 'Oracle's Chamber' and the Room of the Hexagons.

Although painted, many of the designs are similar to the relief carvings of the surface structures.

14 Hypogeum, Hal Saflieni. 'Holy of Holies.' Outline of a 'bull.' 100 cm. x 154 cm. In situ.

This linear representation of a bull which hitherto has been thought to be painted in black pigment, seems to be an illusion for, on close examination, no pigment can be found. Although it appears black, when looked at under strong light at close quarters, the lines appear to be formed only by the smearing of the natural limestone dust mud coating of the walls. A red ochre spiral design which originally covered the area had been wiped through when the 'bull' was formed. Whether intentional or accidental is difficult to say, but compared with the other paintings in the Hypogeum, it may be quite recent.

Unpublished except for 'Guide Book to the Hal Saflieni Hypogeum.' A. J. Agius, 1966

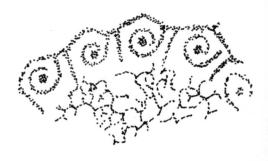

Part of the painted ceiling and wall in the 'Room of the Hexagons'.

The motif on the walls of this chamber is unique in Malta. It is composed of a double row of hexagons, joined together like a honeycomb. In the centre of each is a volute or semi-spiral which branches from the lower left corner of the hexagon, and in the centre of the spiral is a disc. The motif on the ceiling [16] which is different, loosely joins the top of the upper row of hexagons. The painting is worn in places and not all the sides of the hexagons are present.

Ev.M. p. 131

15 Hypogeum, Hal Saflieni. Mural on the wall of an almost circular chamber, between the Great Hall and the 'Oracle's Chamber.' Hexagonal motifs in red pigment, with spiral and disc centres. 8 metres round wall. Each hexagon approx. 56 cm. wide. In situ.

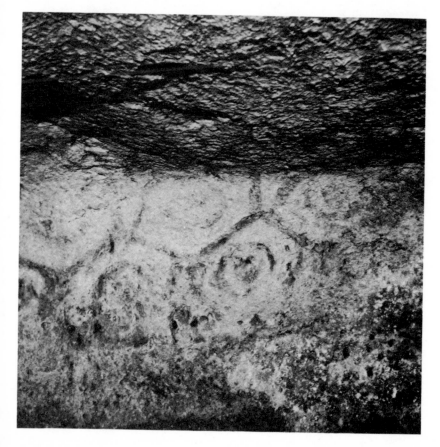

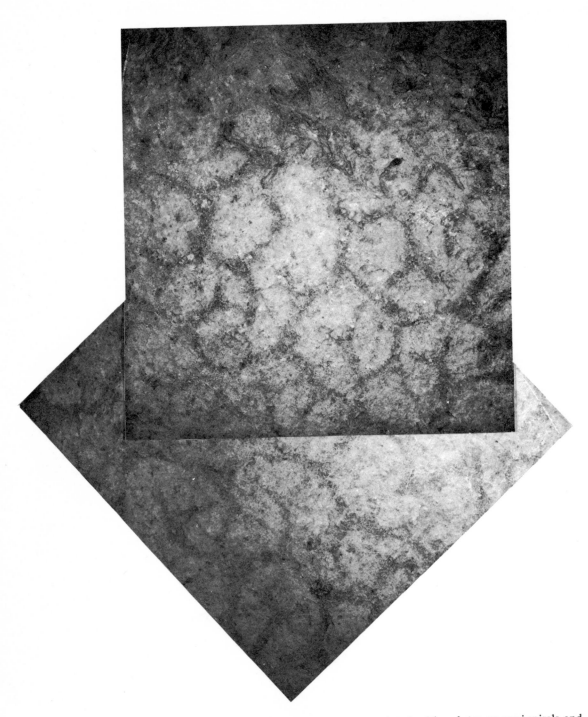

16 Hypogeum, Hal Saflieni. Ceiling painted with volutes or semi-spirals and tendrils, in the room of the hexagons, between the Great Hall and the 'Oracle's Chamber.' In situ.

The design on the ceiling of this room is most complex. It appears, however, that it was formed completely at random from a mass of curves. 'C's,' and forked 'tails' or split tendrils, all connected and entwined. No definite geometric or logical motif can be discerned and yet the ceiling is fully covered in a well-balanced design. The overall effect is of a meandering creeper with many branches and tendrils, but without leaves. The joining with the wall motif [15] is most ingenious and completely harmonious, despite the change from geometric to random motif.

The design seems to be similar, but on a larger scale to 47, 51, 52, 64, 65 and also to 26, 27, 54, 55, 56, 59, 60, 61, 62, 63, 64, 65, although in these cases they conform to logical sequences, while the motif on the ceiling apparently does not. It also seems to be a development of 18.

Ev.M. p. 131

17 Hypogeum, Hal Saflieni. Room of the hexagons. Outline of a hand. 13 cm. x 12 cm. approx. In situ.

Outline of a hand on the wall of the room of the hexagons. This can only clearly be seen in suitable lighting, as the 'image' is formed by shadows, when the light hits the uneven surface of the wall. It appears to be completely accidental, although it is remotely possible that the surface has been pecked away, however this is highly unlikely. No pigment can be seen. If examined with reference to the contours, it will be seen that it has six fingers.

Unpublished except for 'Guide Book to the Hal Saflieni Hypogeum.' A. J. Agius, 1966

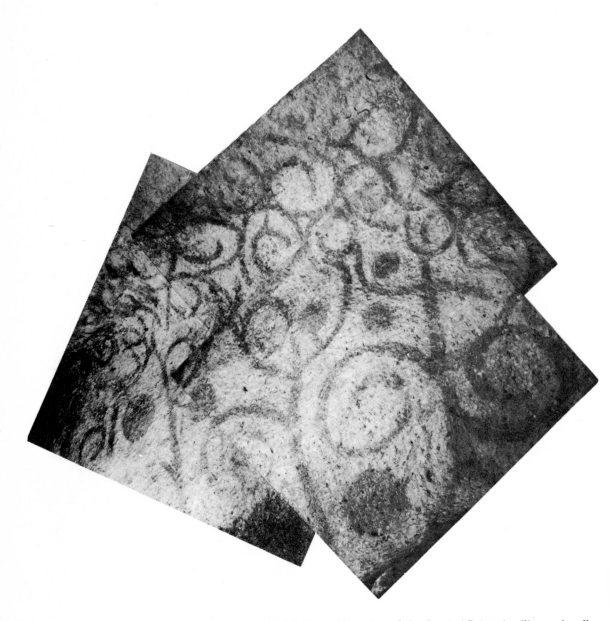

18 Hypogeum, Hal Saflieni. 'Chamber of the Oracle.' Painted ceiling and wall. Approx. 340 cm. x 300 cm. In situ.

This most interesting motif probably contains the clue to the interpretation of the megalithic motifs of both the paintings and reliefs. At first glance, it appears to be formed by a completely random arrangement of spirals, semi-spirals or volutes, tendrils,

forked 'tails,' discs, etc. On closer examination, however, it will be seen that it is formed from three separate 'units' joined together. These 'units' may perhaps best be described as 'trees of life.' Each is formed by a trunk and branches, which when extended to their extremities, form forked 'tails,' or curve in spirals or semi-spirals. Smaller tendrils or branches leave the main branch system. Each 'tree' eventually gets entangled and joined to the other. In between the branches are a number of 'solar' discs, 13 (possibly 14, but now worn). These appear to be floating through the mass of branches unattached to the branches, although in one or two cases a branch touches them. They are of varying sizes, three are much larger than the others. It is possible if an interpretation is to be suggested, that they may be symbolic representations of the Sun as the giver of life. One disc is enclosed completely by a circle. Although found elsewhere in Europe, the circle is rare on Malta.

A number of relief carvings from Tarxien are similar in some aspects to the motifs on this ceiling, for example, **54, 55** and **56** in particular. The combination of spiral and disc on **22** and **23** is also called to mind, as is the disc on **67**.

Ev.M. p. 131, pl. 31
Ug. fig. 73

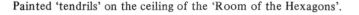

Painted 'tendrils' on the ceiling of the 'Room of the Hexagons'.

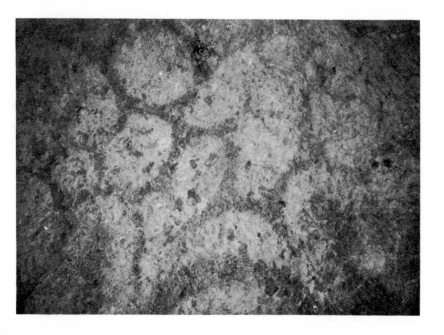

MNAJDRA

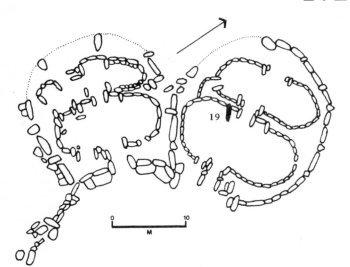

Plan of Mnajdra showing position of 'temple' motif.

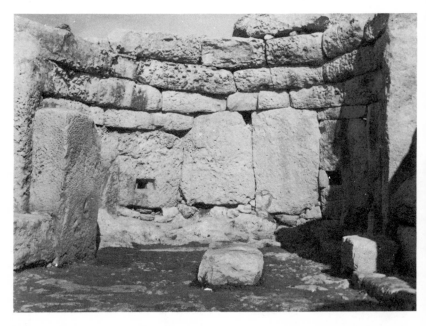

General view of the outer transept of the lower temple of Mnaidra.

The 'temple' of Mnajdra is situated lower down the cliff beneath Hagar Qim, on the west coast of Malta, opposite the island of Filfla. It was excavated in 1840 by C. Lenormant with later excavations by Ashby in 1910, and Evans in 1954. The structure is

better preserved than most 'temples,' and has fared better than Hagar Qim, perhaps because it is low down the cliff, making it difficult to remove stones.

There are two buildings, one lower than the other, both basically of the transepted passage type, although alterations have been made at varying times. They mainly date to LN III.

Although a number of orthostats and blocks, including trilithons are covered with drilled holes, no megalithic art has been found on the site. An engraving has, however, been found, and although not strictly of an artistic nature (it depicts a megalithic building) it has been included [19].

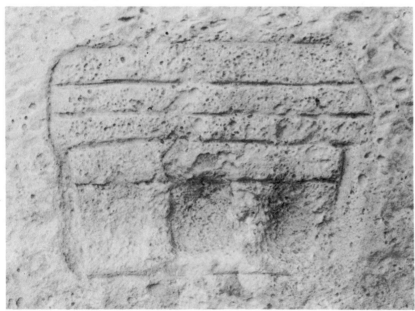

19 Mnajdra. Upper 'temple,' orthostat, facing entrance (on side). Engraving of a building. 33 cm. x 23 cm. In situ.

Although not truly 'art,' this motif has been included, as it gives a valuable idea of the possible original appearance of the megalithic structures, and because no other carved relief or engraved motifs have been found, which have not been included in the book. Therefore, with this engraving the record is complete.

Formed by engraving by pecking, it is in false relief and has some parts hollowed out to a deeper level. The façade and the upper courses of the roof are all shown. Its exact purpose is unknown, although it may have served as a primitive form of architect's drawing.

Ev.M. pl. 76, p. 127

TAL QADI

A small building, it is situated near St. Paul's Bay, between Salina Bay and Naxxar Rd. Although it is very badly damaged, it is thought to date to LN III.

Plan of Tal Qadi.

General view of the temple of Tal Qadi.

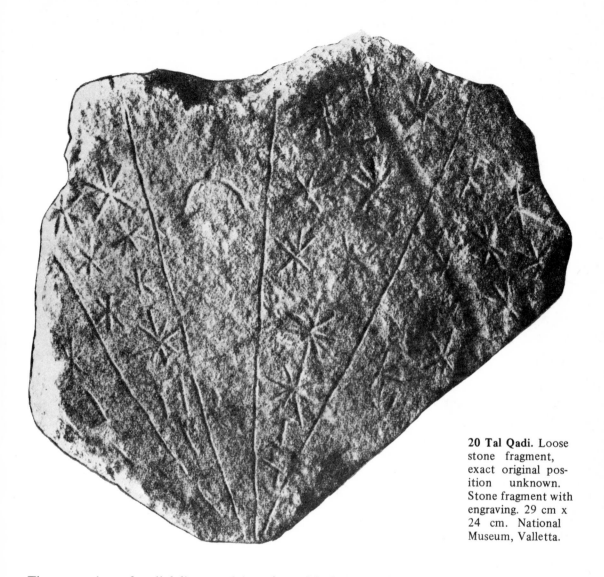

20 Tal Qadi. Loose stone fragment, exact original position unknown. Stone fragment with engraving. 29 cm x 24 cm. National Museum, Valletta.

The engraving of radial lines and 'stars' on this fragment is both unusual and interesting. It is different to the other carvings from the 'temples' both in motif and in execution, i.e. it is engraved.

The fragment is divided into five wedge-shaped segments by four radial lines. In each segment except one, there are 'stars' formed by crossed lines. From left to right there are: one star with three vertical lines, seven 'stars'; empty except for a crescent with a short line beneath it; nine 'stars'; and eight 'stars,' respectively. It is difficult to suggest an interpretation for this motif, it may have had some religious significance or, on the other hand, it might have served some astronomical purpose.

Ug. fig. 79

TARXIEN

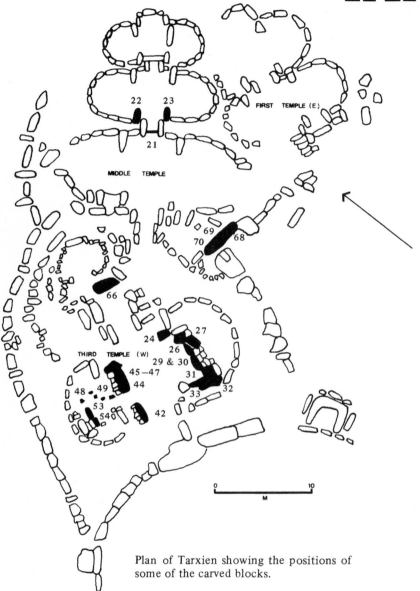

Plan of Tarxien showing the positions of
some of the carved blocks.

The large 'temple' complex of Tarxien is situated near two other
sites, Kordin, and the Hypogeum of Hal Saflieni.

It is a most interesting structure, incorporating three transepted
passage structures, two of two pairs of transepts, and one (the
middle) of three, all having truncated terminal chambers. They are

thought to have been constructed in the order, one to three, East to West. It is possible, however, that this may not be entirely correct, as is suggested by study of the motifs found in the third and second temples. The first temple (E) may date from LN II, while the middle and third temple (W), date to LN III.

The condition of Tarxien is extremely bad, the majority of the masonry of one side and most of the upper courses are missing. However, it preserves the finest megalithic carvings in the Maltese islands, and also the greatest number.

The 'temples' were excavated by Sir Themistocles Zammit, who began operations in 1915. For a full account see 'T. Zammit, Prehistoric Malta, The Tarxien Temples, Oxford, 1930.'

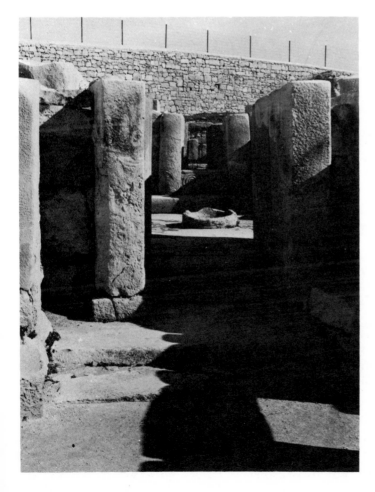

General view of interior of the Middle Temple, Tarxien showing the blocking stone (21) with oculus motif.

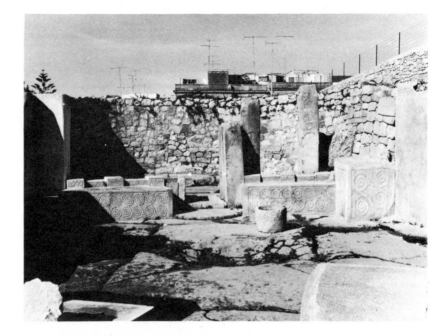

General view of interior of the third temple, Tarxien showing reconstructions of blocks **42, 44, 45.** The two small vertical orthostats in the centre of the picture are engraved with graffiti, **(48, 49, 50).** A 'flower pot' with drilled hole decoration stands in front of block **44.**

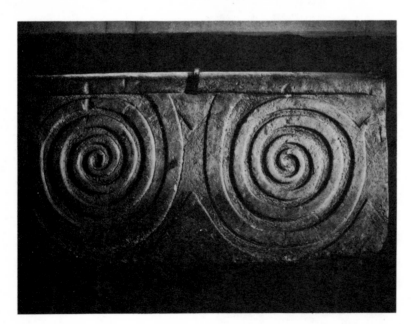

21 Tarxien. Middle 'temple,' blocking entrance to the middle transept. Limestone slab with relief carving. 128 cm x 61 cm. Tarxien Temple Museum.

This large thin blocking stone is carved in relief with a motif of oculus spirals divided by vertical and inverted 'V' wedges. The lower wedge consisting of two crescents under the spirals, which eventually form two further wedges on either side of the spirals.

The left-hand spiral winds clockwise to the centre, the right-hand, anti-clockwise. There are 'horns' on the top right outer ring of the right spiral, and the top left outer ring of the left spiral. There is a thick horizontal relief border on the top of the panel over the wedge and spirals. Similar to Bugibba 1 and 2, Ggantija 6, and Hagar Qim 12.

PMTT p. 27, pl. IX
Ev.M. pl. 26, p. 118

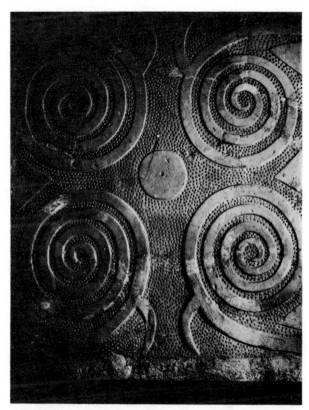

22 Tarxien. Middle 'temple,' middle transepts, west of passage. Large limestone screen carved with motif of double oculus spirals, disc, and with background of drilled holes. 128 cm. x 118 cm. approx. Tarxien Temple Museum.

This block, together with **23**, are unique among the megalithic carvings of the Maltese islands, though there were probably at one time more, as is suggested by fragments **67** and **73**.

The large thin block is decorated on one face with a composition consisting of two oculus spirals on top, two below, with a disc in the centre of the panel, all carved in relief.

The spirals run as follows: top left, clockwise; top right, clockwise; bottom left, anti-clockwise; bottom right, clockwise. Running vertically up each side of the panel are three horizontal wedges, each pointing inwards, one on top, one in the middle and one below. A 'horn' branches off the outer ring of each spiral and

runs toward the outer face. The background is covered with drilled holes. The entire motif is contained within a relief border.

This block is extremely interesting as it is almost identical to **23**, if **23** had been turned horizontal. The lower half of the stone is rough, where another block stood in front.

In its position in the building it faces **23**. Both blocks **23** and **22** screen the eastern and western chambers respectively.

PMTT p. 28, p. IX, fig. 3
Ev.M. pl. 28, p. 119
Ug. op. 74

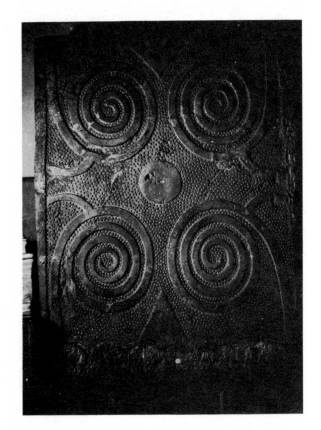

23 Tarxien. Middle 'temple,' middle transepts, east of passage. Large limestone screen decorated with a motif of oculus spirals, disc, and with background of drilled holes. 112 cm. x 138 cm. approx. Tarxien Temple Museum.

The sister block to **22**, it is very similar in motif. The face is carved in relief with a motif composed of two oculus spirals on top, two below with a disc in the centre. There is a 'V' wedge in the centre of the top, and one in the centre of the bottom, both pointing towards the disc. 'Horns' branch off the outer rings of the spirals and gravitate towards the centre of each side. The spirals run as follows: top left, anti-clockwise; top right, clock-wise; bottom left, clockwise; bottom right, anti-clockwise. The background between the relief motifs is filled with drilled holes.

PMTT p. 28
Ev.M. p. 119
Illustrated in 'The Copper Age Temples' Tarxien, Malta, T. Zammit. (A Guide).

The entire design is contained within a relief border. The lower part of the stone is left rough, as another block stood in front.

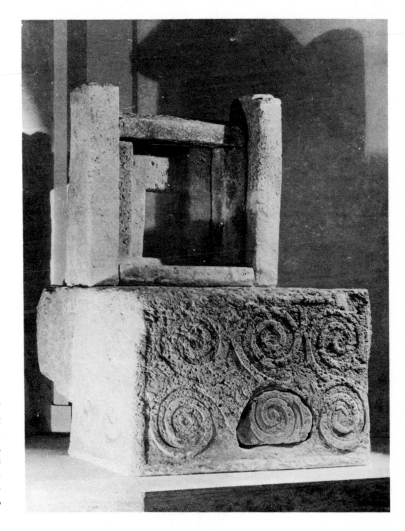

24-25 Tarxien. Third 'temple' (W), first transepts, to right of passage, facing entrance. Large limestone 'altar' block, with two panels carved in relief. **24.** 94 cm. x 78 cm. (side). **25.** 124 cm. x 78 cm. (front). National Museum, Valletta.

A large block carved in relief on two consecutive panels. The motif on both panels is similar.

24. The design is composed of a horizontal reversed 'S' to which above are joined two clockwise spirals. 'Horns' project from the spirals and there is a 'tail' on the top left corner and another between the two top spirals. The top right spiral is worn, There is an area on the far left which has been left rough as it was set in masonry.

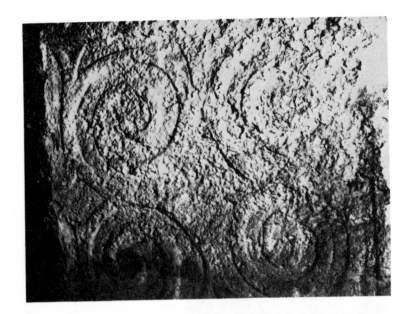

24-25 **Tarxien.** Third 'temple' (W), first transepts, to right of passage, facing entrance. Large limestone 'altar' block, with two panels carved in relief. **24.** 94 cm. x 78 cm. (side). **25.** 124 cm. 78 cm. (front). National Museum, Valletta.

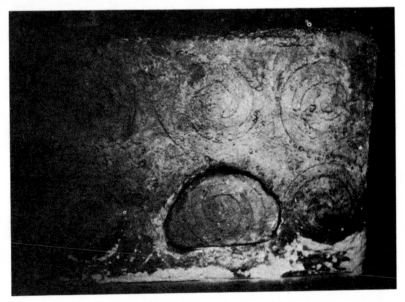

25. Almost the same motif as **24**, but the top left side is worn where the top of a spiral and a 'tail' would have been. On to these are added an additional vertical 'S' spiral with 'horns.' On the bottom line of spirals, the central spiral has been chiselled out, and the interior of the stone hollowed. After this had been achieved a

separate plug was made to fit the space available. It appears that the stone was hollowed out after it had been carved. Numerous charred bones were found in the interior of the block, after the plug had been removed, and a curved flint knife 11 cms. long was found immediately behind it. The other two sides were left blank as they were adjacent to other masonry. Both panels are badly worn.

PMTT p. 14
Ev.M. p. 116

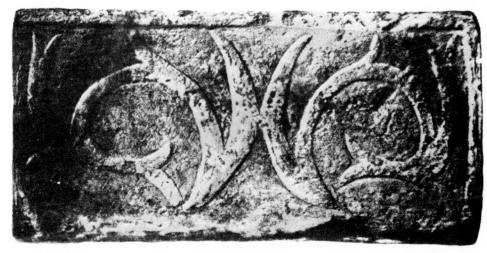

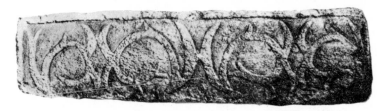

26-27 Tarxien. Third 'temple' (W), first transept (E), to right of **24** and **25**. Long horizontal block carved in relief on two consecutive faces. **26.** 73 cm. x 38 cm. approx. **27.** 149 cm. x 38 cm. National Museum, Valletta.

The block is carved in relief on two consecutive sides, each panel containing a similar motif.

26. The motif on this side panel which faces the passage is composed of two opposed 'C's' with 'horns' and 'tails,' joined by two long 'horns.' Attached at each side is a long vertical 'tail.' The entire motif is within a relief border.

27. The central panel. The motif is similar to **26**, but without the two end 'tails,' instead the design is enlarged by the addition of a further 'C' at each end (the left, reversed) joined to the central motif by two sets of surmounted 'horns,' one set pointing upwards, the other downwards. At each end is a long vertical 'tail.' The motif is in a relief border.

The motif on this block is most interesting for a number of reasons. Firstly, because it is one of the few perfectly symmetrical motifs found in the 'temples,' and secondly, because although it is formed from 'C's' and not true spirals, it follows the same tradition as the oculus spirals [1 and 2, 12, 21]. It also recalls the ceiling motifs of the 'Chamber of the Oracle' at the Hypogeum of Hal Saflieni.

There is a similar motif on pottery. See LAAA pl. XIII. See also Ug. fig. 40, for similar inspiration. PMTT fig. l, p. 14 Ug. fig. 32

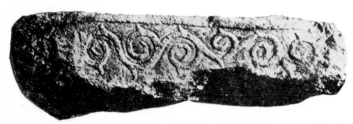

28 Tarxien. Third 'temple' (W), first transept (E), to the right of **26** and **27**. Large horizontal limestone block carved in relief on one face. 136 cm. x 33 cm. (at widest). National Museum, Valletta.

Large horizontal limestone block carved on one face in relief with a motif of 'horned' volutes or semi-spirals. The arrangement appears completely random, though if the spiral at each end is taken to face inwards by necessity of design, then the motif will be seen to be formed by running semi-spirals, or volutes (clockwise), with small branch volutes branching off anti-clockwise to fill the design. All volutes have 'horns.' There are four clockwise and two anti-clockwise. The whole motif is contained within a relief border. There is an unfaced area on the left of the block and although the bottom of the stone appears broken and rough, the design appears to have been carved to fit the area available.

Ev.M. pl. 7, p. 99

29-30 Tarxien. Third 'temple' (W), first transept (E), to the right of **28**. Limestone block with panels on two consecutive sides with relief carvings. **29.** *(right)* 52 cm. x 32 cm. **30.** *(opposite top right)* 130 cm. x 32 cm. National Museum, Valletta.

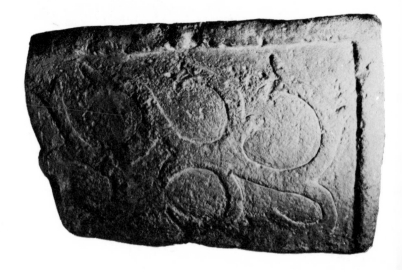

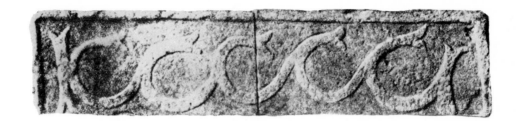

Block **30**

Long narrow block with two consecutive sides carved in relief.

29. The motif is formed by three reversed 'C's,' with 'tails' and 'horns,' supported by three other 'C's' below, the far left with a 'tail.' The simple motif is both unusual and unique. The entire design is contained within a relief border.

30. The motif on this panel is formed by five running 'C's' with 'tails,' and long vertical double 'tails' at each end. The design is within a relief border.

Both motifs are notable for their simplicity.

Ug. fig. 81

View of the first transept (**E**) of the third 'temple' showing replicas of **30, 31, 32, 33, 35.**

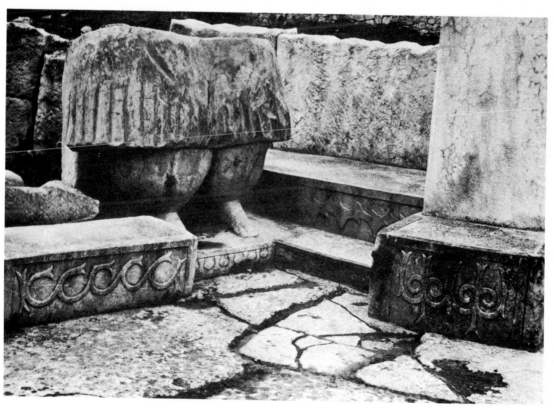

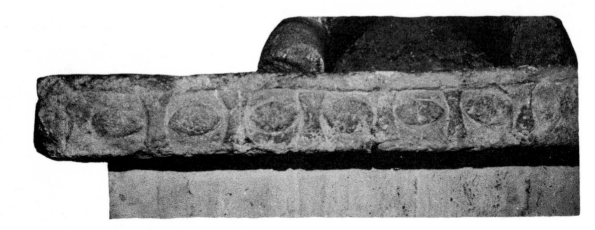

31 Tarxien. Third 'temple' (W), first transept (E) to the right of **30**. Panel with relief motif on the base of a large statue of the 'Mother Goddess.' 14 cm. x 146 cm. National Museum, Valletta.

The motif carved on this panel is both unique and interesting. It consists of a row of horizontal ovoids with pointed ends, 'eggs,' separated by vertical 'double axes' or concave and convex lines. The right end is badly worn, and no motif remains. A horizontal border covers the design.

Ug. fig. 80

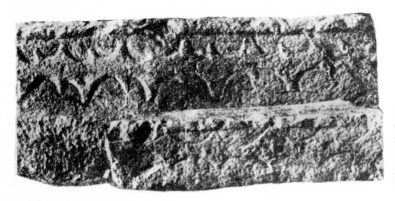

32 Tarxien. Third 'temple' (W), first transept (E), to the right of **31**. Limestone block with one face carved in relief. 240 cm. x 58 cm. National Museum, Valletta.

33 Tarxien. Third 'temple' (W), first transept (E), in front of **32**. Limestone block with one face carved in relief. 95 cm. x 20 cm. National Museum, Valletta.

The motif on block **32** is extremely interesting, principally due to its dissimilarity to the other motifs. The design, is a continual horizontal shape, with rounded 'horns' projecting both up and downwards in what appears at first random points, but when examined carefully, follows a definite rhythm. The entire motif is within a relief border.

The best label that can be attached to this design is that of 'sea-weed' which it closely resembles. However, the 'horns' may be related to other motifs, and have other significance. The design is also found on pottery. A smaller block decorated with a similar motif, stood in front of the right side of the block. There is a rough area 13 cm. high beside this block [31], running towards the left side, probably another block stood in front.

Apart from the design, there are several other interesting features worth noting. The left side of the block has a simple relief border enclosing a quadrilateral of smoothed stone but containing no motif. It is as if this side was intended to be seen, but from the position in which it was found (it was adjacent to another block), it would not have been visible. The left side of the front panel, although faced is blank, and the lower half of the block is rough. The back of the block has a motif of drilled holes within a relief border.

Tarxien. Reverse of block 32, showing drilled holes and relief border.

The above suggests that the block was not originally intended for the area it occupied, and may well have been re-used, after some earlier alteration to the buildings. Alternatively, reference to the

For replica of block, see Ug. fig. 34, p. 94, however they may not be entirely accurate. For pottery motif in the same tradition, see PMTT fig. 29 and p. 113.

plan suggests that many of the stones in this area may have, in fact, been moved, as the transept behind them is almost sealed off by their present positions.

33 is a small block with 'seaweed' motif, similar to 32. The motif beneath a horizontal relief border, is more symmetrical than 32, and the 'horns' are more pointed. A similar motif occurs on the pottery.

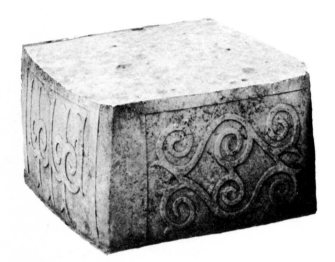

Tarxien. Reconstruction of panels 35 and 36.

34-35-36 Tarxien. Third 'temple' (W), first transept (E), to the right of **33**. Limestone block with carved panels in relief on three consecutive sides. **34.** 47 cm x 64 cm. (motif (47 cm. x 38 cm.) **35.** 47 cm. x 81 cm. (motif 47 cm. x 50 cm.) **36.** 47 cm. x 64 cm. National Museum, Valletta.

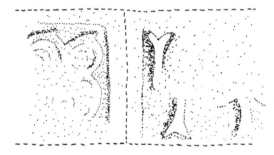
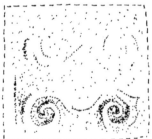

This block is most unusual, in that each panel is carved with a different motif, and with the possible exception of **35**, closely resemble other motifs found in the third 'temple.' All three sides are very badly worn and it is difficult to distinguish accurately the complete motif on each panel. The reconstruction at present in the 'temple' is not strictly accurate.

34. Motif formed by two 'S' spirals with 'horns.' It appears, how-

ever, that they were not true 'S' spirals, but similar to those on **42**, i.e. enclosed vertical oculi. Very badly worn.

35. This central panel is unusual in that it appears to have been formed by long vertical 'tails' with 'horns' at each end and possibly in the centre. This is, however, conjectural as only one end 'tail,' two vertical 'trunks' and parts of three 'C's' are visible. The reconstruction could therefore be similar to **43**, **54**, **55**, or **56**.

36. This panel is too badly worn to trace much of the original design, the motif, however, appears to be very similar to **44**, being constructed from two conjoined rows of running spirals with 'horns.'

All motifs, **34**, **35** and **36** are within relief borders.

For hypothetical reconstruction of 34, see Ug. fig. 34
For hypothetical reconstruction of 35, see Ug. fig. 94.

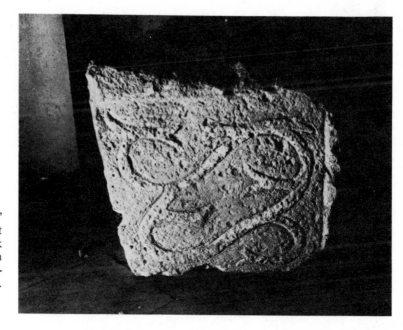

37 Tarxien. Third 'temple' (W), first transept (E), next to **36**. Small limestone block with panels carved in relief on two consecutive sides. (37-38). 32 cm. x 29 cm. approx. Tarxien Temple Museum.

Small oblong block with two consecutive sides carved in relief. Originally within relief borders, but now badly worn, as is the whole block.

37. The design is composed of a simple motif of two horizontal 'S's' with 'horns' and 'tails,' conjoined one above the other. Badly worn.

38. The front panel. Composed of three tight spirals each with 'horns.' The two spirals on the left run anti-clockwise, the one on

the right, clockwise. The far left and the far right spirals are joined as oculi, with the central spiral branching from the right spiral. Badly worn.

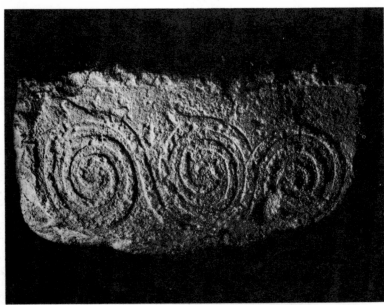

38 **Tarxien**. Third 'temple' (W), first transept (E), next to **36**. Small limestone block with panels carved in relief on two consecutive sides. (37-38). 32 cm. x 60 cm. Tarxien Temple Museum.

39 **Tarxien**. Third 'temple' (W), first transept (W), opposite side of passage to **38**. Limestone block with two panels decorated on two consecutive sides, one with drilled holes, the other with panel carved in relief. 35 cm. x 29 cm. Tarxien Temple Museum.

39. This panel is decorated with drilled holes within a relief border. It is unusual as in the position in which it was discovered, adjacent to another block, it would not have been seen as the panel would have been completely covered. This occurs several times at Tarxien, see **32**. It is possible that these stones are not in their original positions, but if they are, then these hidden drilled holes must have held some other significance or purpose. There is some damage to this side and also to **40**.

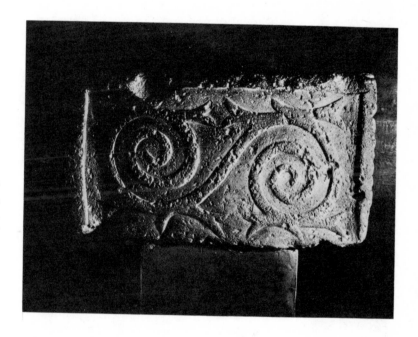

40 Tarxien. Third 'temple' (W), first transept (W), opposite side of passage to **38**. Limestone block with two panels decorated on two consecutive sides, one with drilled holes, the other with panel carved in relief. 59 cm. x 30 cm. Tarxien Temple Museum.

40. The central panel, it faces the passage. The motif is formed from a horizontal tight 'S' spiral with 'horns' and two horizontal opposed 'tails' with 'horns' on both the top and the bottom of each spiral. The entire design is within a relief border.

Here we have the basic spiral, elaborated with 'tails.' This panel more than any other, probably points to some ritual significance of the 'tails,' as they are basically alien to the motif. The opposed 'tails' seen on this piece seem almost a development of the opposed 'horn' and 'tail' seen on **37**.

41. Side panel with a small motif of a simple horizontal reversed 'S,' with 'tails' and 'horns' and a small curved extension towards the front of the block, this with 'horns' and 'tail.' The majority of the panel is unworked as it was covered by an adjacent block.

Ev.M. pl. 24
PRMI p. V, left

41 **Tarxien.** Third 'temple' (W), first transept (W). Large horizontal limestone block, carved in relief on three consecutive sides (**41, 42, 43 a, b, c, d, e, f, g**). The top of the block with five miniature standing key blocks, each carved with relief motifs. Next to **40**. Facing passage. Motif 32 cm. x 10 cm. National Museum, Valletta.

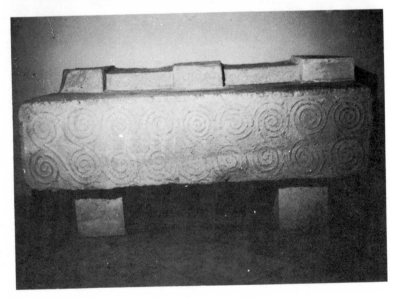

42 **Tarxien.** Third 'temple' (W), first transept (W). Large horizontal limestone block, carved in relief on three consecutive sides (**41, 42, 43 a, b, c, d, e, f, g**). The top of the block with five miniature standing key blocks, each carved with relief motifs. Next to **40**. Facing passage. 46 cm. x 190 cm. National Museum, Valletta.

42. Centre panel. This panel is one of the most complicated of all the motifs. It consists of an elaborate spiral system composed in the following manner:

The bottom left spiral flows outwards from its nucleus, clockwise, until it curves like a 'C' up the left edge of the panel. It then

returns and curves upwards in a large semi-circle, then in a diagonal direction downwards until it curls anti-clockwise in another spiral towards the nucleus. A similar design is made in reverse so that a square is formed by the two extended spirals. On to this a large figure '3' extends to the right, eventually joining up with the square of spirals. A series of large figure '3's' then extend from the first figure '3.' Within the space enclosed by these figure '3's' are a series of vertical oculus spirals, clockwise and anti-clockwise. There are seven figure '3's' with vertical oculi in each. Each spiral is embellished with 'horns.' The whole motif is contained wthin a relief border. The design gives a misleading impression that it is composed of running 'S' spirals similar to the Mycenaean, but this is not the case.

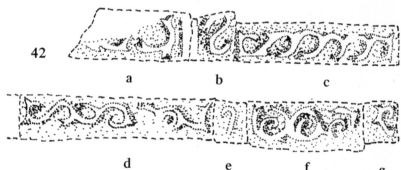

42

a b c

d e f g

42a. Top left key block. Very badly damaged, only the remains of a reverse 'C' with 'tails' can be discerned. Originally within a relief border.

42b. Side panel between **a** and **c**. Motif of 'S' with 'tails' within a relief border.

42c. Second key block. Motif composed of a horizontal 'S' on to which a series of four reversed 'C's' are attached in running order. All embellished with 'horns' and 'tails.'

42d. Side panel between **c** and **e**. Motif of elongated reversed 'C' with multiple 'horns' and 'tail.'

42e. Third key block. Motif composed of a series of three spirals running clockwise with 'horns' and 'tail' at each end.

42f. Side panel between **e** and **g**. Motif badly worn and difficult to discern, but similar to **d**, in reverse.

42g. Fourth key block. Motif composed of a series of random 'C's' reversed and elongated, with 'tails' and 'horns.' The fifth key block badly damaged, no motif could be recorded.

42 a, b, c, d, e, f, g, Tarxien. Third 'temple' (W), first transept (W). Large horizontal limestone block, carved in relief on three consecutive sides (41, 42, 43). The top of the block with five miniature standing key blocks, each carved with relief motifs. Next to **40**. Facing passage. **42. a** 13 cm. x 26 cm. **b** 12 cm. x 9 cm. **c** 10 cm. x 41 cm. **d** 10 cm. x 8 cm. **e** 12 cm. x 31 cm. **f** 11 cm. x 8 cm. **g** 10 cm. x 47 cm. National Museum, Valletta.

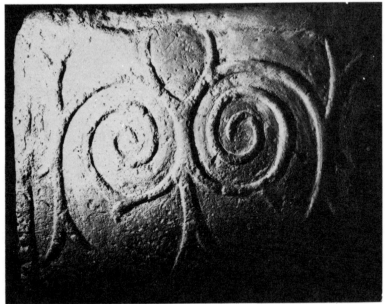

43 Tarxien. Third 'temple' (W), first transept (W). Large horizontal limestone block, carved in relief on three consecutive sides (41, 42, 43 a, b, c, d, e, f, g). The top of the block with five miniature standing key blocks, each carved with relief motifs. Next to 40. Facing passage. 45 cm. x 55 cm. approx. National Museum, Valletta.

43. The side panel of 42. The motif is unusual and extremely interesting. It is basically oculus spirals which branch outwards at each end till they form long 'tails,' on to which large vertical 'tails' extend upwards. In between the oculi is a 'tail' which extends downward like the trunk and roots of a tree. Two large 'horns' branch on the top of each spiral, towards each other like a pair of animal horns. The entire motif is contained within a relief border.

42c is similar to 30, upside down; 42e similar to 52, but with tight curls, and 42g similar to 58, 59, 61, 62 and 63 (one line).

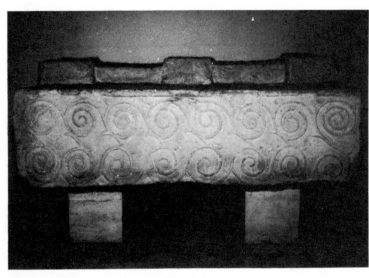

44 Tarxien. Third 'temple' (W), first transept (W). Large horizontal limestone block, carved on one face with a panel in relief. The top of the block with five miniature standing key blocks, each carved with a panel in relief. Next to 45, 46, 47. Facing passage. 166 cm. x 44 cm. National Museum, Valletta.

44. The composition is formed by two rows of spirals with 'horns,' one above the other and joined together. The top row consisting of eight spirals, running anti-clockwise towards the centre, except the far right, which runs clockwise. The top left and bottom right spirals could, in fact, be described as 'S' spirals. The top right spiral is unusual in that it has more turns than the others. The entire motif is within a relief border.

a, b, c, d. The top key blocks, five in number (3 small and 2 long) were carved in relief on one face. Due to damage and wear it is not possible to record all the motifs.

44a. First key block. The motif is composed of joined circles with opposed 'horns' on top and long curving 'horn' inside the circle.

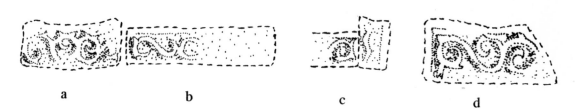

a b c d

44 a, b, c, d Tarxien. Third 'temple' (W), first transept (W). Large horizontal limestone block, carved on one face with a panel in relief. The top of the block with five miniature standing key blocks, each carved with a panel in relief. Next to **45, 46, 47.** Facing passage. **44.** 166 cm. x 44 cm. **a** 38 cm. x 12 cm **b** 37 cm. x 9 cm. **c** 37 cm. x 10 cm. **d** 28 cm. x 13 cm. National Museum, Valletta.

The motif is unique, but similar to **52.** Badly worn, and both ends of the panel are too damaged for record.

44b. Second key block, badly damaged. All that can be recorded is a reversed horizontal 'S' with 'horn' and part of another. It is possible that the design could continue in opposed fashion. Originally within relief border. The third key block is too worn to record.

44c. Fourth key block, very badly worn. All that can be recorded is at the far end, where part of an 'a' with 'horn' can be discerned similar to **51.** At the side is a panel between the fourth and fifth key blocks with a vertical serpentine motif.

44d. Fifth key block. This is the best preserved of the key blocks. The motif consists of a reversed horizontal 'S' with 'horns' and a 'tail' on the bottom left, to which is added an inverted 'C' with 'horns.' Originally within a relief border. Similar to **38.**

Ev.M. pl. 24, p. 116
PRMI p. V
PMTT p. 15

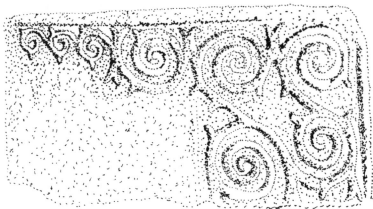

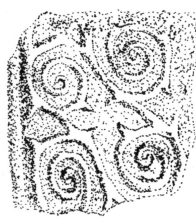

45-46-47 Tarxien. Third 'temple' (W) first transept (W), adjacent to **44**. Companion 'altar' block to **24-25**. Limestone block carved on two consecutive sides and on the horizontal top. **45.** 144 cm. x 71 cm. (facing entrance). **46.** 83 cm. x 71 cm. **47.** 135 cm. x 73 cm. approx. National Museum, Valletta.

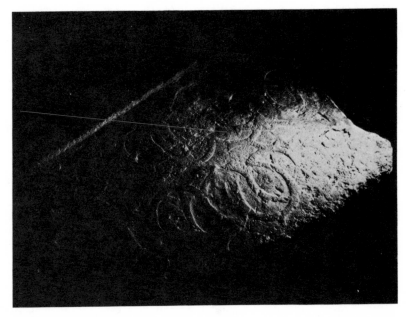

This block is unique as it is the only block carved in relief on a horizontal surface. It is also interesting as it gives clues to the original positions of stones, and how and when they were carved.

45. The motif on this panel has been made to fit the area available after the block had been fitted into position adjacent to **44**. This indicates that this stone, if not others, was carved after it was placed in position. It also suggests that blocks **44**, **42** and **40** are in their original positions. The motif has been composed to fit the area available for decoration. There is a rough stepped area of un-faced stone immediately adjacent to **44**.

The major area has been filled with a composition composed on four large spirals arranged on two layers one above the other, with 'horns' and 'tails' between, on the top row, and on the right lower corner. At first they appear to be joined 'S's' but in reality they are two clock-wise spirals joined to a horizontal reversed 'S' spiral with anti-clockwise turns. The space to the left, immediately above the rough unfaced area is filled with a row of four small conjoined spirals, running anti-clockwise with 'horns' and with a vertical double-sided 'tail' between the third and fourth.

46. Side panel similar in design to **45**, but composed of two horizontal reversed 'S' spirals, with 'horns' and a 'tail' branching vertically from the middle of the top 'S.' There is some damage to the lower spirals.

The design of **45** and **46** is very similar to **24** and **25**, the sister block, which is in a similar position on the opposite side of the passage. The design also recalls **40** and **42**.

47. The top panel is unfortunately very badly worn, but it is possible to make out the greater part of the motif. The reconstruction at present in position in the 'temple' is not strictly accurate.

The whole surface is carved with a mass of double opposed interlocking 'C's', with 'horns' and 'tails'. Although it appears quite at random, it conforms to a strict rhythm, and produces a similar effect in relief to the painted ceiling in the room of the hexagons in the Hypogeum of Hal Saflieni, **16**.

PMTT pl. II (right) and p. 15
PRMI pl. IV (right)
Ev.M. pl. 23 (reconstruction) and p. 116

48 Tarxien. Third 'temple' (W), first transept (W), entrance passage. Limestone orthostat with graffiti. 57 cm. x 67 cm. approx. (drawn area). In situ.

There are two orthostats, one with graffiti on one face [48], the other on two [49, 50]. Each is engraved with the representations of a number of ships. The techniques and tools used for their manufacture vary considerably, some are deep while others are very faint. The block is weathered, but it is possible to discern a number of ships. It is not possible to suggest with certainty when they were made. It has been suggested that they are contemporary with the 'temple,' but the writer is of the opinion that they are later, as they in no way tie in with the motifs current during the period, nor are they comparable in quality or technique. It could be argued that they were made by unskilled hands, a kind of 'Kilroy was here,' this, however, seems unlikely especially if one bears in mind the sacred nature of the buildings.

A full account is given in Antiquity XXXI, 1957, 'Graffiti of Ships at Tarxien, Malta,' by Diana Woolner. A number of ships which she identifies can no longer be seen.

49 Tarxien. Third 'temple' (W), first transept (W), entrance passage. Limestone orthostat with graffiti. 75 cm. x 70 cm. approx. (drawn area). In situ.

50 Tarxien. Third 'temple' (W), first transept (W), entrance passage. Limestone orthostat with graffiti. 31 cm. x 59 cm. approx. (drawn area).

49

50

The second of two orthostats with graffiti, see description of **48**.
This face is very badly worn and only a few of the ships that Diana Woolner identified can be traced.
See Antiquity XXXI, 1957 'Graffiti of Ships at Tarxien, Malta,' by Diana Woolner.
The narrow side face of **49**. See descriptions of **48** and **49**. This face is very badly weathered and only a few of the ships that Diana Woolner identified can be traced.
See Antiquity XXXI, 1957 'Graffiti of Ships at Tarxien, Malta,' by Diana Woolner.

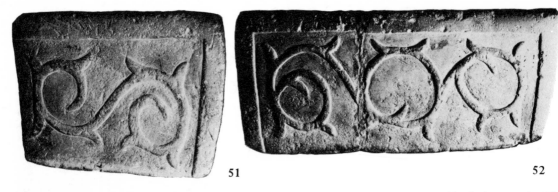

51 52

51-52 Tarxien. Third 'temple' (W), first transept (W), interior. Small limestone block decorated with relief carvings on two consecutive sides. **51.** 27 cm. x 20 cm. (side). **52.** 50 cm. x 20 cm. (front). Tarxien Temple Museum.

The 'curling' with 'horns' can be compared with similar 'curling' and 'horns' on a potsherd from Tarxien, see PMTT fig. 31

The designs of both panels **51** and **52** are in relief borders.

51. The motif on this panel is basically a horizontal 's' with 'horns,' almost a development of a single 's' of **37.**

52. This motif is more sophisticated than **51,** though perfectly in keeping with it. It consists of an 'a' joined with two 'o's,' each elaborated with 'horns.' This motif is most unusual, with several unique features. For the first time we see the 'c' extended to touch itself forming and 'a' and 'o' respectively. It is also one of the rare occasions that the circle features in Maltese megalithic art. It is similar to the motif on **64** and **65,** and also to **42e, 44a & 44c.**

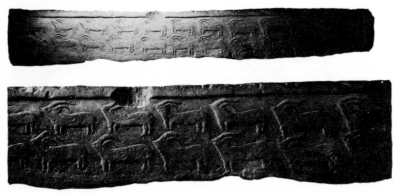

53 Tarxien. Third 'temple' (W) first transept (W), interior, facing end of transept. Large horizontal limestone block, carved in relief with a naturalistic motif of animals, on one face. 200 cm. x 29 cm. Tarxien Temple Museum.

PMTT p. 17 (Zammit's measurements of this block are inaccurate. He also states that the animals are male but no sexual organs are shown).

This block is similar to **57,** one of the few panels decorated with naturalistic motifs. The design is composed of two rows of goats or rams, facing left; 22 in all. Unlike **57,** the sexual organs are not shown. The entire motif is within a relief border. There is some wear to the block, especially to the left side.

92

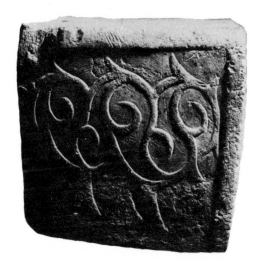

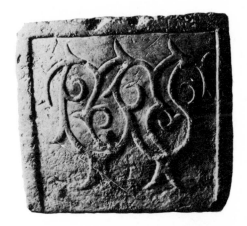

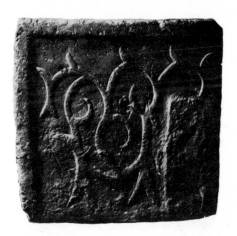

54-55-56 Tarxien. Third 'temple' (W), first transept (W), interior. Limestone block with three consecutive sides carved in relief. **54.** 33 cm. x 33 cm. **55.** 33 cm. x 40 cm. **56.** 33 cm. x 34 cm. Tarxien Temple Museum.

This block is decorated with three of the most unusual motifs. **54** and **55** are almost identical, while **56** is a variation.

54. This most strongly reminds one of the ceiling of the 'Chamber of the Oracle' in the Hypogeum, **18**, with its tree trunks and entwined branches. The composition consists of two 'trunks' with 'roots' (vertical 'tails') on to which are attached three branches (one common). The motif is almost impossible to describe, but it appears to have been formed by a top line of conjoined running 'C's' with 'horns,' joined to a base of two 'Y' 'trunks' with a small 'c' branching from the middle of the 'Y.' The whole within a relief border.

55. Basically the same as **54**, with the addition of some 'horns' and 'tails.' Within a relief border.

56. Basically the same as **54,** but the design has been altered to leave a small vertical rectangular area, to the back of the block, which was left rough as it was covered by another block. The motif is composed of two 'trunks' (vertical 'tails') which link together, from which a 'C' branches in the middle of the link. On to this above, are attached a row of two running 'C's' with 'horns' and 'tails,' and the beginning of another 'C.' Within a relief border.

PMTT pl. III
PRMI pl. VI, left.
Ug. fig. 33

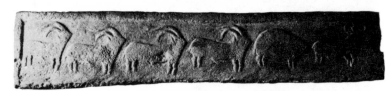

57 Tarxien. Third 'temple' (W), first transept (W), interior, facing entrance to transept. Limestone block carved in relief with naturalistic animals on one face. 104 cm. x 19 cm. Tarxien Temple Museum.

One of the few blocks carved in relief with a naturalistic motif. The panel is decorated with representations of six animals facing right in procession. From right to left they are: Ram (note horns), pig, and four goats (or sheep?). The motif is within a relief border on two sides only. There is no border on the right side, but the remains of half a rope hole show that the block was originally larger. The other section has not been found.

PMTT pl. III (3), p. 17
Ev.M. fig. 23, p. 151
PRMI pl. VI
Ug. T. IX

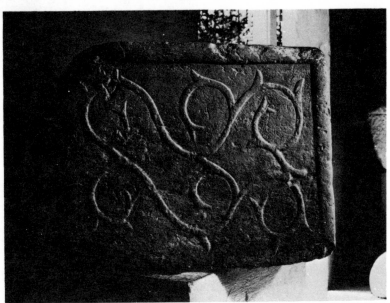

58 Tarxien. Third 'temple' (W), first transept (W), interior. Next to **57,** not necessarily in its original position. Limestone block carved in relief on three consecutive sides. 41 cm. x 32 cm. Tarxien Temple Museum.

One of the few blocks that are decorated on three consecutive sides. The motifs are both informative and interesting.

58. The composition consists of a horizontal reversed 'S' with 'horns' and 'tails,' joined to another above, on to each of which is added a reversed 'C' with 'horns' and 'tails,' each joined to the other.

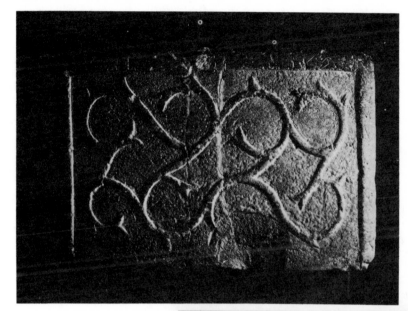

59 Tarxien. Third 'temple' (W), first transept (W), interior. Next to 57, not necessarily in its original position. Limestone block carved in relief on three consecutive sides. 48 cm. x 32 cm. Tarxien Temple Museum.

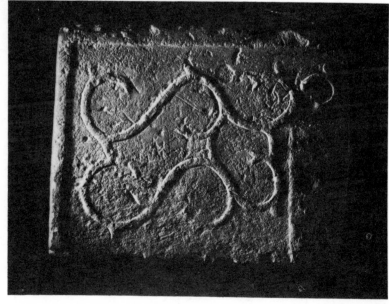

60 Tarxien. Third 'temple' (W), first transept (W), interior. Next to 57, not necessarily in its original position. Limestone block carved in relief on three consecutive sides. 42 cm. x 32 cm. Tarxien Temple Museum.

59. The motif on the central panel is more interesting. The top line is composed in a similar manner to **58.** A horizontal reversed 'S' with 'horns' and 'tails,' joined to two reversed 'C's' with 'horns' and 'tails,' one branching upwards, the other downwards. On to this arrangement is added below a horizontal 'S,' with a 'C' to the left and a reversed 'C' to the right, all with 'horns' and 'tails.' The central 'S,' however has been modified to suit the area available, as the lower half of the stone has been damaged. This indicates [see also **60**] as do some of the other blocks, that they were mainly carved in situ.

60. The motif is very similar to **58.** The left side consists of two horizontal 'S's' with 'horns' and 'tails,' joined together, one above the other. The motif on the right half of the panel, however, has been dictated by the space left after the stone had been placed next to another. The design has been made to fit the available space and this has caused the motif to become extremely unusual. On the top line a reversed 'C' branches out from the horizontal 'S' and another much smaller 'C' branches from this. Below a large reversed 'C' branches from the horizontal 'S' and is then connected with the upper line of the motif by a small curve. Both 'C's' have 'horns' and 'tail.' A rectangular area is left rough. All motifs **58, 59** and **60** are within relief borders.

The design of **59** is identical to **62.**

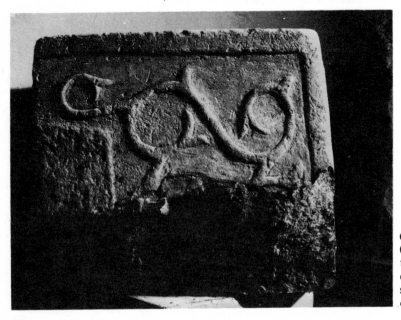

61 Tarxien. Third 'temple' (W), first transept (W), interior. Limestone block carved on three consecutive sides with relief motifs. 40 cm. x 33 cm. approx.

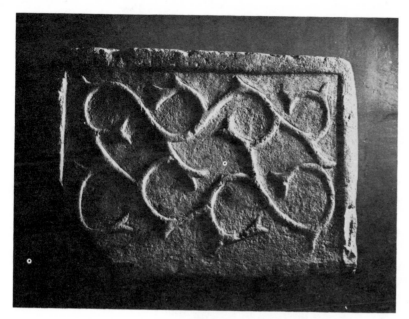

62 Tarxien. Third 'temple' (W), first transept (W), interior. Limestone block carved on three consecutive sides with relief motifs. 49 cm. x 33 cm.

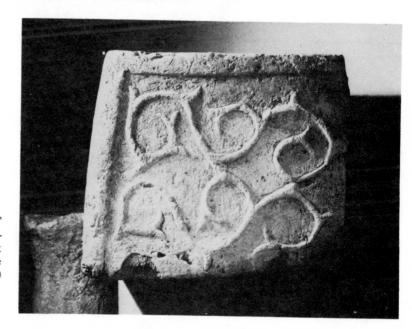

63 Tarxien. Third 'temple' (W), first transept (W), interior. Limestone block carved on three consecutive sides with relief motifs. 40 cm. x 33 cm.

This block is very similar to **58, 59, 60**, in fact, the central panel **62** is almost identical to **59**, except for the area where the design is slightly altered due to damage.

61. This panel is badly damaged in the lower half. The design, however, has been made to fit the area left after leaving a vertical rectangle at the back of the block (left side of panel). The motif consists of a large reversed horizontal 'S' with 'horns' and 'tails' on to which has been added a small elongated 'C' with 'tail,' to the left. It is not possible to determine with certainty when the damage occurred to the block, but it was possibly after the carving had been completed. The motif is within a relief border.

62. The motif of this panel is composed of two rows of linked 'C's' as follows: The top is a reversed horizontal 'S' with 'tails' and 'horns' to which is added two reversed 'C's' with 'horns' and 'tails.' Attached to, but under this line is a line, starting with two 'C's' with 'horns' and 'tails,' attached to a horizontal reversed 'S' with 'horns' and 'tail.' The entire motif within a relief border.

63. Similar motif to **61** and **62**. The design is composed of two rows of linked 'C's' as follows: On the top row is a reversed horizontal 'S' with 'tails' and 'horns,' to which is added a reversed 'C' with 'tail' and 'horns.' On the bottom line, but attached to the top is a reversed horizontal 'S' with 'tails' and 'horns,' to which is attached a reversed 'C' with 'tail' and 'horns.' A duplicate of the top line.
The motif is within a relief border.

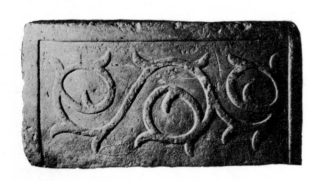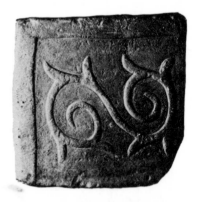

64-65 Tarxien. Third 'temple' (W), first transept (W), interior. Limestone block carved on two consecutive sides with relief motifs. **64.** 47 cm. x 22 cm. (centre). **65.** 24 cm. x 22 cm. (side). Tarxien Temple Museum.

Small block carved with motifs on two consecutive faces, very similar to **51/52**.

64. Composed of a horizontal 'S,' which is tightly curled to form an 'e' joined to an 'a.' On to this is joined a reversed 'C,' 'horns'

elaborating the whole. The motif is within a relief border.

65. Composed of a reversed horizontal 'S' with 'horns,' the ends tightly curling, but not touching the body.

66 Tarxien. Third 'temple,' immediately in front of terminal chamber at end of passage. Large horizontal limestone block (in two parts), carved in relief on one face. Large panel only shown. For reconstruction of entire block see page 100. 75 cm. x 277 cm. (large) 44 cm. x 67 cm. (small). National Museum, Valletta.

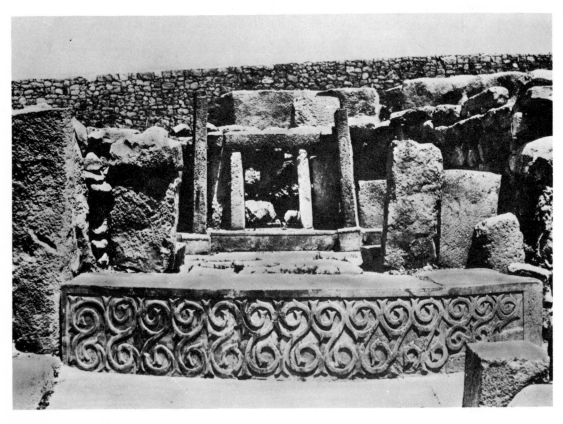

Tarxien. View of terminal chamber of the third 'temple' showing a replica of **66.**

The largest of the carved blocks in the Maltese islands, its design is developed and sophisticated.

The motif, which is contained within a relief border, is composed of two rows of 'C' spirals. The top line starts on the left with a horizontal reversed 'S,' on to which are added a row of reversed 'C' spirals, all with 'horns' and 'tails.' There is a vertical 'tail' between each 'C.' The bottom row is formed by a row of reversed 'C' spirals which branch off the outer ring of the spirals of the top row, all have 'tails' and 'horns,' and there is a 'tail' which hangs down from the join between each 'C.'

The design continues on to the smaller stone to the right but is reduced in size. This is an interesting feature, as the lower half of the stone is damaged, therefore the design has been made to fit the space available, and was carved after the stone was damaged.

There are several other interesting features. Under the main design there is an area contained within a relief border, with a decoration of drilled holes. This is divided in two by a vertical relief band. When in situ these holes and the border were not visible. Here again we have the possibility that the stone may have been re-used, or that the drill holes have other significance.
Reminiscent of **25** and **44**.

Ev.M. pl. 25, p. 117

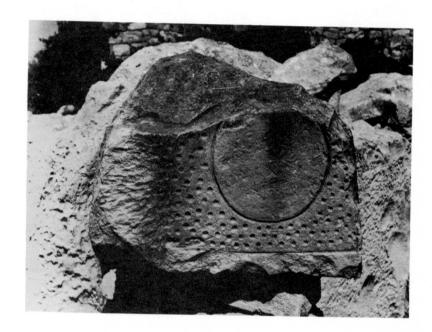

67 Tarxien. At present in terminal transept at the end of the passage of the third 'temple.' Limestone fragment carved in relief. Found amongst masonry. 33 cm. x 20 cm. In situ.

This small fragment is carved with part of a disc, in relief, the background filled with drilled holes. It appears to have come from a screen similar to **22** and **23**. The presence of fragments such as this, stones badly damaged and others not in their original positions, suggest that the 'temples' originally housed many more carved blocks than now exist.

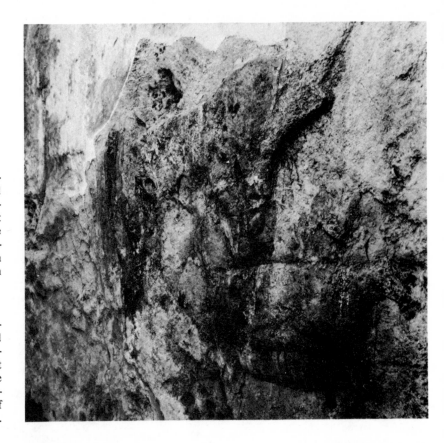

68 Tarxien. Room between the third and middle 'temple', entered from the first transept (SE) of the middle 'temple'. Naturalistic relief carving of a bull on orthostat. In situ.

69 Tarxien. Room between the third and middle 'temples,' entered from the first transept (SE) of the middle 'temple.' Naturalistic relief carving of an animal. In situ.

PMTT pl. VIII, p. 25
Ev.M. fig. 25, p. 151

There are three naturalistic representations grouped together on two orthostats in a room made from part of the area originally occupied by the second transept (E) of the third 'temple' and the first transept of the second 'temple' (middle).

68. This representation of a bull is immediately above another carving, popularly known as the 'sow' [**69**]. The bull faces towards the right, facing another bull **70**. The outline is extremely simple and effective.

Although the relief is worn, it is unlikely that there was any inner detail.

69. This relief is badly worn in places. It consists of an animal in a similar position to **68**, but without male sexual organs. The area between the forelegs and hindlegs is arched, under which are thirteen vertical cylindrical objects. A horizontal line joins the forelegs with the hindlegs almost touching the tops of the 'cylinders.'

This representation has been called a 'sow' suckling her farrow. It is difficult, however, to accept this suggestion. If the animal is compared with the pig on **57**, it will be seen to be different, even allowing for a possible difference in sex. Further study of **57** and **68** will reveal that the sculptors were well capable of representing accurately the species of animal they intended to portray. It is therefore unusual that the animal should look more like a cow than a sow.

The 'cylinders' beneath are even less like piglets. They remind one of the sacred objects (phallic symbols as Zammit called them) illustrated in Zammit's 'Tarxien Temples,' plate XXIV. (excavation Nos. T 518, T 519).

PMTT pl. VIII, p. 25
Ev.M. fig. 25, pl. 151

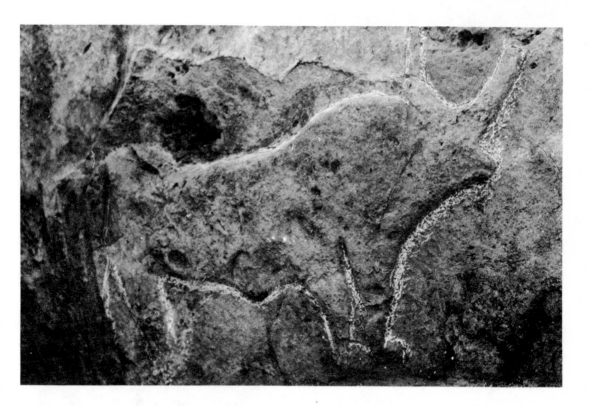

70 Tarxien. Room between the third and middle 'temples,' entered from the first transept (SE) of the middle 'temple.' Naturalistic relief carving of a bull on orthostat. In situ.

The outline is simple and similar to **68**, which it faces. Although worn, it is unlikely that there was any inner detail.

PMTT pl. VII, p. 25
Ev.M. fig. 25, p. 151

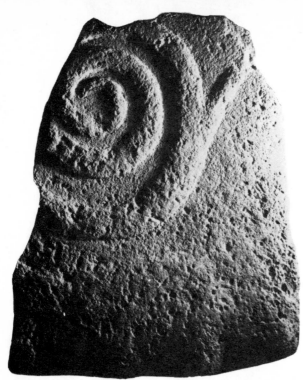

71 Tarxien. Position uncertain. Large fragment of limestone blocking slab, carved in relief. 55 cm. x 69 cm. Tarxien Temple Museum.

This fragment, carved in relief with a large spiral with 'horn' is part of a large blocking slab similar to **1** and **2, 12, 21.**

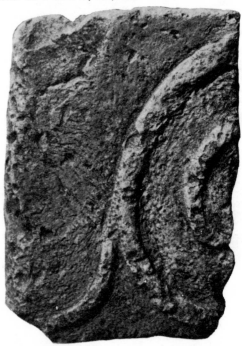

72 Tarxien. Exact location unknown, found in 1970 in temple garden. Limestone fragment with motif carved in relief. 30 cm. x 42 cm. Tarxien Temple Museum.

Small fragment, carved in relief with a spiral with 'horn,' part of a small blocking slab with oculus spirals, similar to **1 and 2, 12, 21.**

73 Tarxien. Position unknown. Limestone fragment, carved in relief with part of a spiral, with background of drilled holes. 32 cm. x 18 cm. Tarxien Temple Museum.

A fragment of a large block, probably a screen similar to **22** and **23**. Although parts of the above screens are missing, this does not fit and, therefore, belongs to another example.

Lower half of the large mother goddess in the outer transept, third temple, Tarxien. Three dimensional sculpture is discussed in the chapter on 'Pottery and Sculpture.'

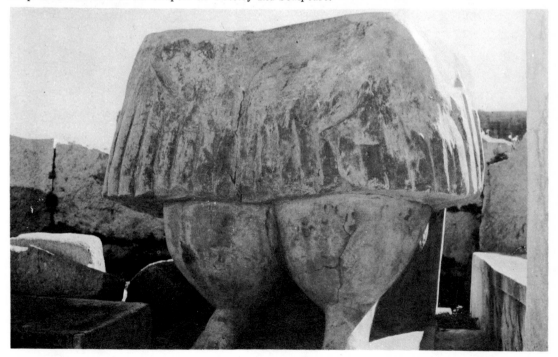

TAS SILG

Tas Silg on the S.E. coast of Malta, overlooking Marsaxlokk Bay, is one of the sites that is being excavated by the Italian Archaeological Mission in Malta. Although the Mission's excavation was mainly concerned with uncovering remains of the Punic and Roman periods, the remains of a megalithic building were encountered, and a statue of the 'Mother Goddess' recovered. See reports of 'Missione Archeologica Italiana A Malta.' Centro Di Studi Semitica, Istituto di Studi del Vicino Oriente, Universita Degli Studi Di Roma.

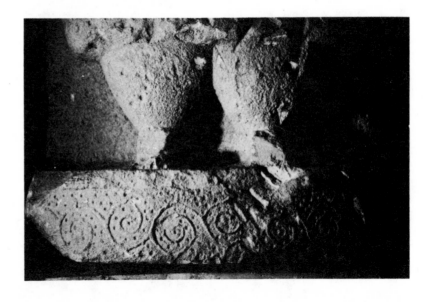

74 Tas Silg. Area of megalithic structure. Small horizontal panel with relief carvings on the base of a 'Mother Goddess.' 11 cm. x 48 cm. National Museum, Valletta.

Francis S. Mallia, Rapporto preliminare della Campagna 1964. Missione Archeologica Italiana A Malta, Roma 1965 (p. 75) Centrol di Studi Semitici, Istituto di Studi Vicino Oriente.

The Mother Goddess statue was excavated during the 1964 campaign, from an area of a megalithic structure, by the Italian Archaeological Mission in Malta. There is some wear and damage to the panel.

The motif consists of random spirals with 'horns' like tendrils of a vine, eight in all. The background between the relief is filled with drilled holes. There is a relief border above.

XROBB IL GHAGIN

The ruins of a small megalithic building are situated on the cliffs on the S.E. coast of the island. The building is very badly damaged and hardly recognisable, the majority having slipped over the cliff edge. A large horizontal slab carved with a relief border and decorated with drilled holes was, however, recovered from the site and is now in the National Museum. The building is thought to date from LN.I.

75 Xrobb il Ghagin. Limestone block with drilled holes. National Museum, Valletta.

A small area of a large horizontal block decorated with drilled holes. The holes are within a relief border.

This is included as a sample of the drill decoration that covers stones in a number of buildings. Sometimes the stones are decorated with drilled holes within relief borders, and other times with the holes alone.

The reverse of block **32** which has a relief carving on the front has its back covered with drilled holes. Block **66** at Tarxien has panels of drilled holes beneath the main relief, which would probably not have been visible when in situ. In many cases, however, drilled holes were an integral part of the relief decoration as in blocks **22, 23, 67, 73** at Tarxien, and on the pillar altar (**13**) and blocking stone (**12**) at Hagar Qim.

At Mnajdra, blocks occupying similar positions to the carved blocks at Tarxien and Bugibba have their surface covered with drilled holes, mainly within carved relief borders. It may be that the holes acted as an anchor for relief stucco work.

ZEBBUG

A small group of five tombs discovered at Zebbug have produced one of the most interesting and important pieces of Maltese megalithic art, a head of a statue-menhir.

For a full account see J. G. Baldacchino and J. D. Evans 'Prehistoric Tombs near Zebbug.' Papers of the British School at Rome, Vol. XXII (N.S. IX), 1954, pp. 1-21.

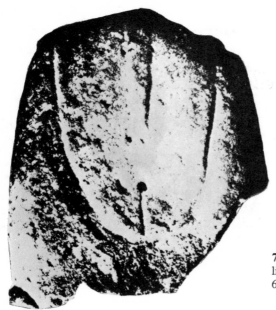

76 Zebbug. Tomb 5, Ta Trapna. Head of a limestone statue-menhir. 19 cm. x 15 cm. x 6.5 cm. National Museum, Valletta.

Head of a statue-menhir, the features formed by vertical grooves and holes. The face is long and oval, the nose, delineated by two vertical lines with two holes for nostrils, and near the top of the vertical lines are two further holes which may represent eyes. The mouth is a simple drilled hole from which a short vertical line runs to the chin. There is a wide vertical groove down the back of the stone. The face is raised from the body of the stone in shallow relief.

This sculpture is unique in Malta, it is also the oldest specimen of megalithic carving in the Maltese islands, dating to circa 3200 B.C. For comparison we must look to the statue-menhirs of the South of France, Spain and Italy, although in all these cases the similarity is only slight. The technique also differs, the Maltese example is in shallow relief, while those mentioned above are cut into the rock. A similar technique for representing the mouth is employed on the plank-idols of Cyprus.

Ev.M. pl. 48, p. 62
Ev.PPS/53, p. 79

CHRONOLOGY

Since radiocarbon dates were first introduced, archaeologists have noted a discrepancy between radiocarbon dates and known historical dates, in particular the Egyptian King lists. This discrepancy has now been able to be measured and a correction curve calibrated on the basis of dates obtained by dendrochronology, tree ring dating. This was achieved by using exceptionally long lived trees, the Californian bristlecone pine *(Pinus aristata)* which grows in arid conditions at a height of between 3000-3500 metres above sea level. These trees are extremely long lived with lives extending over many thousands of years. One of the oldest trees dates back 4,900 years, and a tree ring chronology has already been established covering some 7,100 years. By calculating the date of trees and wood samples (by counting the annual growth rings) and then comparing them with the radiocarbon dates of the same specimens, a differential was obtained which enabled a recalibration curve to be put forward. Generally speaking radiocarbon dates before 1500 B.C. are younger than the tree ring dates. The rift is exaggerated the older the radiocarbon date making it necessary for an adjustment to be made of up to 500 years.

Recalibrated radiocarbon dates for Malta.

PERIOD	TYPE SITE	RADIOCARBON DATE	RECALIBRATED DATE
Early Neolithic III	Red Skorba	3225 ± 150 B.C.	3980 B.C.
Middle Neolithic I	Zebbug	3190 ± 150 B.C.	4000 ± 100 B.C.
		3050 ± 150 B.C.	3740 B.C.
Middle Neolithic II	Mgarr	2700 ± 150 B.C.	3440 ± 40 B.C.
Late Neolithic III	Tarxien	2430 ± 150 B.C.	3090 ± 90 B.C.
Early Bronze Age I	Tarxien Cemetery	1930 ± 150 B.C.	2350 ± 130 B.C.

It should however be borne in mind that the recalibrated dates are not absolute as the technique is still in its infancy and there are many discrepancies. For this reason all the dates quoted in this book are based on uncalibrated radiocarbon dates.

The introduction of recalibrated radiocarbon dates heralds a revolution in archaeology. For many of the existing cultural relationships are challenged, and if altered, completely change the face of a great part of the ancient world. Not only that, the dates in fact challenge the very basis of archaeology, the everyday techniques on which archaeological knowledge has been built. In fact the old established 'diffusion' theory of the spread and development of culture has already been challenged and a 'new' 'anti-diffusionist' school is rapidly establishing itself.

The recalibration of radiocarbon dates has created a rift or fault line separating the areas of historical dates, i.e. Egypt and Mycenae and the areas where the chronology has been based on radiocarbon dates, i.e. the Western Mediterranean, Europe and Britain. This fault line occurs at the borders of the historically dated regions running in a curve drawn from Italy and the West Mediterranean through Yugoslavia and Bulgaria to the Black Sea.

Perhaps the most significant results for European archaeology, especially British, is the chronological rift which now separates the Wessex culture of Britain, from Mycenae, thereby making it impossible for Mycenaean influence in any form to affect the culture.

Before overthrowing all that has been established in an enthusiastic rush for 'new' and 'better' knowledge, the validity of the techniques and results must be thoroughly tested and placed within accurate statistical limits. Caution must be the key word. Bearing this in mind we can examine the results and implications of the recalibrated dates when applied to Maltese prehistory.

In Malta several things happen when we change the dates. The 'temples' become the oldest known stone buildings in the ancient world pre-dating the pyramids by many centuries. In addition the earliest rock-cut tombs of the Mediterranean are found in Malta at Xemxija and Hal Saflieni. It is interesting too, to note that the recalibrated dates for the Neolithic period now correspond to Zammit's guess made over 60 years ago. Another change affects the Zebbug menhir, it is now a millenium older, and is therefore one of the oldest examples of statue menhirs in prehistory.

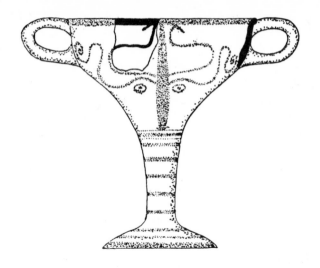

Sherd of Mycenaean pottery from Borg in-Nadur and a drawing of a Mycenaean chalice showing how the sherd would fit into the vessel.

The temple culture (Late Neolithic III) is now over well before 2000 B.C., the recalibrated radiocarbon date for period Late Neolithic III being approximately 3090 ± 90 B.C. As the end of the succeeding period Early Bronze Age I is dated to about the 13th century B.C. by the presence of a sherd of Mycenaean III B pottery, found associated with material of Middle Bronze Age I. We must on the face of it anchor the end of the period at around the 13th/14th century B.C., at the same time stretching the beginning of the period backwards so it adjoins the end of the temple culture Late Neolithic III. This results in an extremely long period Early Bronze Age I of well over a millenia. However this need not be so, for Zammit's excavated evidence from Tarxien suggests that some considerable time elapsed between the temple culture (Late Neolithic III) and the cemetery culture (Early Bronze Age I). He recorded that a layer of some 1 metre of 'sterile silt' separated the Neolithic from the Bronze Age, and cited Sir Arthur Evans to show that a similar deposit in Crete would represent a period of 1000 years. Whatever time lapse we allocate to this layer, we can be reasonably sure that there was a time gap between one culture and the other, although this may only be applicable to Tarxien.

Much of what is now indicated by the recalibration of Maltese radiocarbon dates was anticipated by my study of the megalithic motifs recorded in this book (written in 1969, first published in 1971.). Therefore the relative chronology between motifs put forward on the basis of artistic development may prove to be of use in examining the development and decline of the temple culture, for many of the designs of the reliefs are reproduced on the pottery.

It is clear that Maltese prehistoric culture developed to a great degree in isolation and I have shown on artistic grounds that the comparisons between the Maltese spirals and Mycenaean are purely superficial. The artistic differences between the Mycenaean, Maltese, and Minoan spirals outlined in this book are further strengthened by the now considerable chronological rift between the cultures. A chronological rift which makes it impossible for Mycenaean and Minoan influence to be felt in Malta, in any way.

The religious and philosophical ideas which developed in Malta may have had an influence on the religious and perhaps religio/artistic ideas of the Eastern Mediterranean, but cannot be proved. However we cannot deny that a religious force of great magnitude must have been prevalent in Malta over many centuries for so many 'temples' to have continued to have been constructed and altered. Artifacts are fossilized ideas. The Maltese 'temple' with its internal religious art is more than that, it is a fossilized religious belief and philosophy of a whole community. An idea which did not develop in a year, or even in ten, but one which developed and lasted over more than one and a half millenia.

It seems unreasonable to assume that all cultural and technological ideas in the ancient world developed from one seed. It seems equally unreasonable to assume that every cultural, technological and religious idea, in the numerous cultures of the world, developed as original thought in total isolation, the argumentive extremes of diffusionist and anti-diffusionist policy. In Malta with the new recalibrated dates the problems of diffusion are further emphasised. The similarity on the one hand of the religious ideas and of artistic expression with those of the Eastern Mediterranean especially with Crete and Mycenae, and on the other the great time gulf between the cultures, now further exaggerated by the re-calibrated dates.

It is strange that such complex religious ideas, trees of life, and worship of vegetation and fertility, not only grew up independently, but found expression in almost identical ways, but separated by a considerable gulf of time. Ideas exist, they are abstract and cannot generally be traced, especially if unrecorded by material artifacts (much of which, even if they existed, would by their very nature be perishable). Thus ideas and philosophies are not destroyed by time, they exist as an invisible influence.

It is possible that at a time when Maltese megalithic culture was in ruins, its echo could have been reflected in a culture widely

separated by both time and space? Such a question can never be adequately answered.

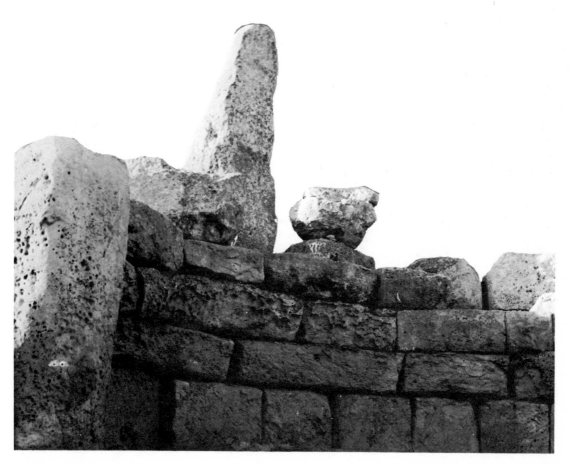

POTTERY AND SCULPTURE

The aim of this book has been to examine the origin and growth of one particular form of prehistoric art, that of the megalithic relief carvings of Malta. Although it has been both necessary and possible to examine this art in isolation, from the artistic point of view, it must be remembered that the megalithic reliefs are only one artistic outlet of the Neolithic culture of Malta. There were other means of artistic expression, which can be associated with the reliefs, and in many cases found in the same context. They are the three dimensional sculpture, both large and small, in limestone, alabaster and other stones, together with terracotta figurines, and the numerous decorative motifs found on pottery.

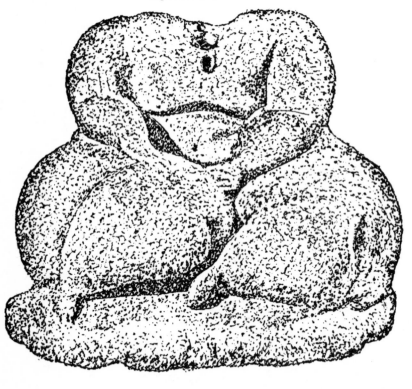

Above: Seated limestone figure from Hagar Qim.

Right: Deformed terracotta female figure from Mnajdra.

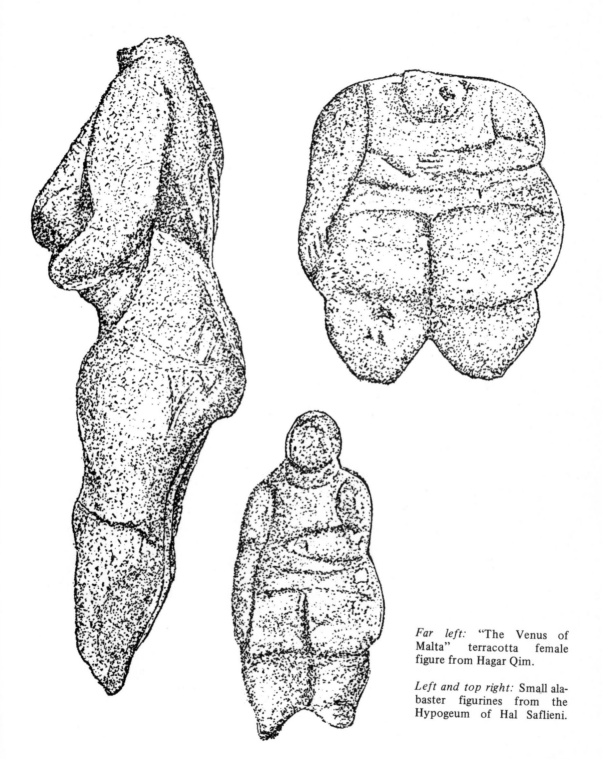

Far left: "The Venus of Malta" terracotta female figure from Hagar Qim.

Left and top right: Small alabaster figurines from the Hypogeum of Hal Saflieni.

It is not possible to include a detailed study of these in this book, but a few words are necessary to give, perhaps, a better visual background with which to associate the reliefs.

The sculpture, with minor exceptions, tends to be figurative and almost entirely devoted to magico-religious purposes. The most common figure is an obese female which we can safely consider to be a goddess or priestess and probably a fertility symbol. She is shown either seated with her legs tucked to one side, or standing upright. Her head is almost invariably missing, and in some cases was actually made as a separate part which could be attached to the main body. In some cases it may have been possible through a device to affect movement of the head by a cord. The figures are mostly shown with the hands folded together on the lap, or occasionally with one resting on the thigh. They are mostly naked,

"The Sleeping Lady", terracotta model of a reclining woman from the Hypogeum of Hal Saflieni.

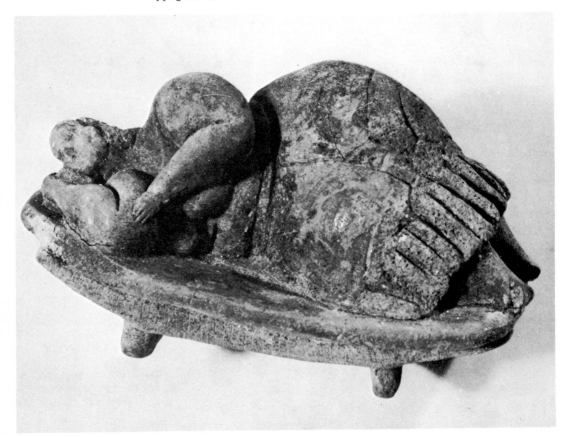

although there is an example from Hagar Qim which is shown wearing a dress with a bell-like skirt. "The Sleeping Lady" from the Hypogeum of Hal Saflieni is also shown wearing a dress, as is a figure from Tarxien. In the case of both the latter, the skirt appears to be fluted. The Tarxien figure has been taken to be a priestess. The figures range from a height of just a few centimetres to the giant mutilated figure found at Tarxien, which when complete would have stood nearly 2.75 metres high. On the western exterior wall of Hagar Qim there are the fragmentary and badly worn remains of the lower halves of two relief mother goddesses, which seem to follow the normal pattern of the three dimensional examples.

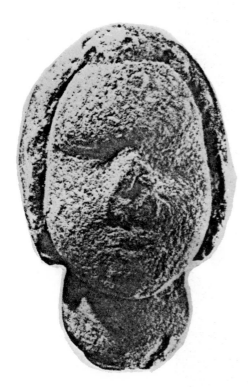

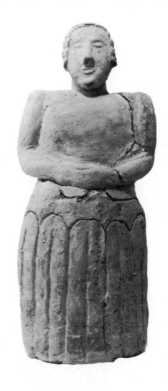

Left: Limestone head from the Hypogeum of Hal Saflieni.
Right: Reconstruction of a terracotta figure from the head and fragments of the body found at Tarxien.
Above right: Drawing of a stylised terracotta head found at Tarxien.

The purpose of these figures is not at all clear, as a study of them will reveal a variation in type, and therefore they may have fulfilled more than one purpose. In the case of the larger and more formal sculptures, we can attribute a position of "goddess" while some of the smaller figures and figurines may infact be votive offerings. A number of these small figurines greatly emphasise the sexual characteristics, while others are mutilated and deformed. In the case of the latter we may be dealing with sympathetic magic, the figures being intended either to cure a deformity, or perhaps even to induce one. The figure of the mother goddess from Tas

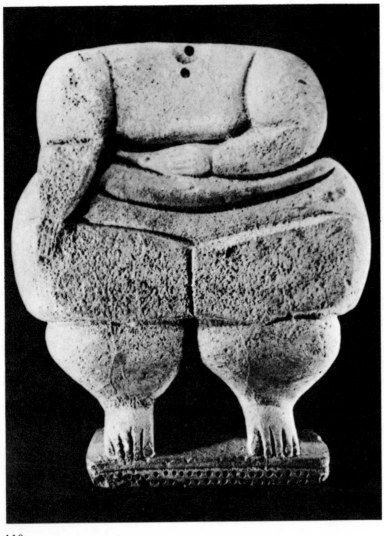

Headless standing limestone figure from Hagar Qim.

Silg along with the large mother goddess from Tarxien are the only direct association between the megalithic relief carvings and the sculptures. At Tarxien, the relief on the plinth of the sculpture (31) takes the form of "eggs," separated by vertical "double axes" or concave and convex vertical lines. At Tas Silg (74) the small horizontal panel on the front of the plinth is decorated with a motif of random spirals, with horns like tendrils.

Seated limestone figure wearing a dress, from Hagar Qim.

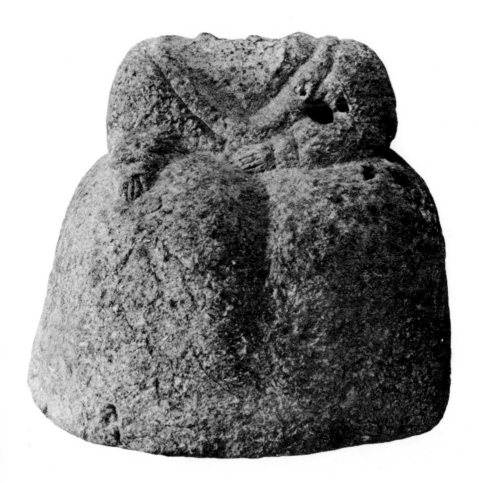

The association between the pottery and both the megalithic reliefs and the sculpture is very strong. For apart from a scratched figure of a "goddess" or "dancing girl" found on a pot-sherd from Tarxien, a number of other designs seen on the reliefs, are paralleled on the pottery, including curvilinear,abstract and animal designs. The relationship between the designs on the pottery and the relief carvings seems to be important. While most of the designs of the relief carvings appear on the pottery in some form or other, some pottery designs are not found in the relief carvings. Although we now have a firm typological sequence for the pottery, it may be possible by comparisons between the pottery and the relief carvings to obtain a sequence of sub-divisions within the pottery types.

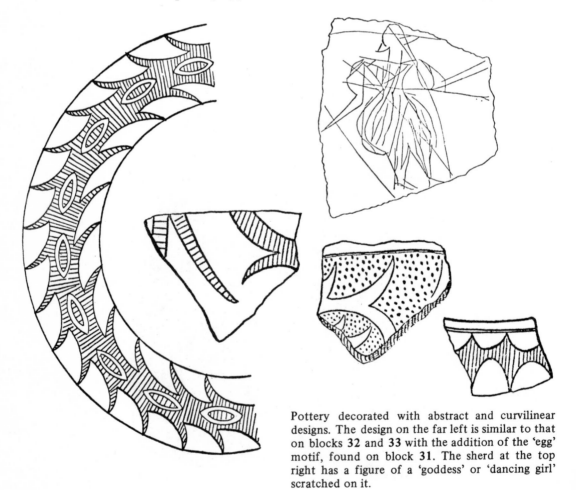

Pottery decorated with abstract and curvilinear designs. The design on the far left is similar to that on blocks **32** and **33** with the addition of the 'egg' motif, found on block **31**. The sherd at the top right has a figure of a 'goddess' or 'dancing girl' scratched on it.

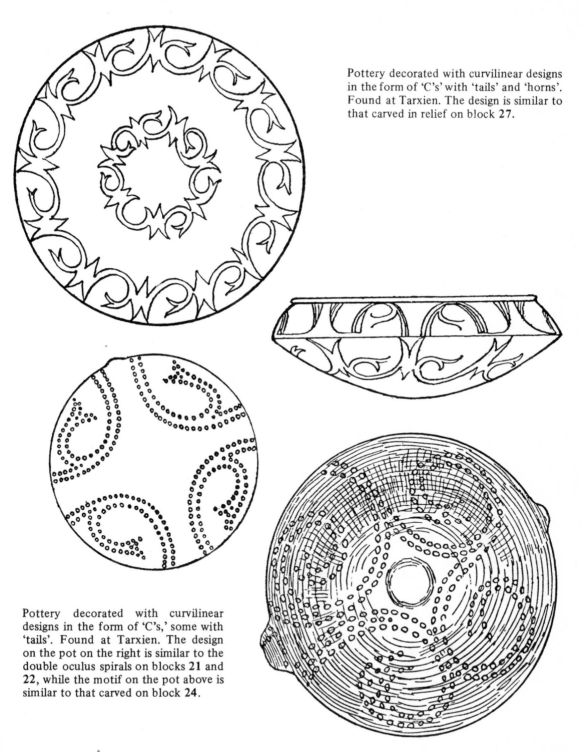

Pottery decorated with curvilinear designs in the form of 'C's' with 'tails' and 'horns'. Found at Tarxien. The design is similar to that carved in relief on block **27**.

Pottery decorated with curvilinear designs in the form of 'C's,' some with 'tails'. Found at Tarxien. The design on the pot on the right is similar to the double oculus spirals on blocks **21** and **22**, while the motif on the pot above is similar to that carved on block **24**.

BIBLIOGRAPHY

Ashby, T., Bradley, R. N., Peet, T. E., Tagliaferro, N. *Excavations 1908-11 in various megalithic buildings in Malta & Gozo.* Papers of the British School at Rome. Vol. VI. 1913, p. 1-126.

S Brea, L. B. *Sicily,* London 1966.

PRSPI Breuil, H. *Les Peintures Rupestres Schematiques de la Peninsule Iberique.* 4 vols. Lagny 1935.

Breuil, H. & Burkitt. *Rock Paintings of Southern Andalusia.* 1929.

PAP Breuil, H. *Presidential Address* to Prehist. Soc. E. Anglia 1934.

MASMS Cardozo, M. *Monumentos Arqueologicos de Sociedade Martins Sarmento.* 1950.

MBWE Daniel, G. E. *The Megalith Builders of Western Europe.* London 1963.

AA Demargne, P. *Aegean Art.* London 1964.

Eogan, G. *The Knowth Excavations.* 1967. Antiquity 41 : 302-4.

Ev./PPS/53 Evans, J. D. *The Prehistoric Culture Sequence of the Maltese Archipelago.* Proceedings of the Prehistoric Society. 1953.

Ev.M Evans, J. D. *Malta.* London 1959.

Evans, J. D. *The Prehistoric Antiquities of the Maltese Islands.* London 1971.

B Giot, P. R. *Brittany.* London 1960.

Sd. Guido, M. *Sardinia.* London 1963.

Herity, M. *Irish Passage Graves.* Dublin 1974.

Hutchinson, R. W. *Prehistoric Crete.* London 1962.

Hyde, H. P. T. *The Geology of the Maltese Islands.* Malta 1955.

McW MacWhite, E. *A New View of Irish Bronze Age Rock-scribings.* Journal of the Royal Society of Antiquaries of Ireland. 76 : 59-80.

M/PPS Mahr. *Presidential Address.* Proceedings of the Prehistoric Society, New Series Vol. III, part 2. 1937.

 Mallia, F. S. *The Prehistoric Material, Tas Silg.* Rapporto Preliminare della Campagna 1965. Missione Archaelogica Italiana A Malta. Rome.

VD Mayr, A. *Die Vorgeschichtliche Denkmaler von Malta.* Munchen 1901.

 Mayr, A. *The Prehistoric Remains of Malta.* Malta 1908.

 Mayr, A. *Die Insel Malta in Altertum.* Munchen 1909.

EM Murray, M. A. *Excavations in Malta.* 3 vols. London 1923, 1925, 1929.

 O'Kelly, M. J. *New Grange Co. Meath.* Antiquity 38 : 288-90. 1964.

 O'Kelly, M. J. *Excavations at New Grange.* Antiquity 42 : 40-2. 1968.

NG O'Riordain, S. P. & Daniel, G. E. *New Grange.* London 1964.

AC Pendlebury, J. D. S. *The Archaeology of Crete.* London 1939.

CSGMMM Pequart, M. and Le Rouzic, Z. *Corpus des signes graves des monuments megalithiques du Morbihan.* Paris 1927.

NCBI Piggott, S. *The Neolithic Cultures of the British Isles.* Camb. 1954.

AE Piggott. S. *Ancient Europe.* Edinburgh 1965.

ByG Powell, T. G. E. and Daniel, G. E. *Barclodiad y Gawres.* Liverpool 1956.

PA Powell, T. G. E. *Prehistoric Art.* London 1966.

BCA Renfrew, C. *Before Civilization and After*. Cape.

CR/WA/70 Renfrew, C. *New Configurations in Old World Archaeology*.
 Published in World Archaeology 1976 Volume 2.

 Ridley, M. R. *Some Problems of Maltese Prehistory*. Text of
 lecture given at the 7th Conference of Young Archaeologist, Unv.
 of Birmingham. January 1969.

 Savory, H. N. *Spain and Portugal*. London 1968.

LAAA Tagliaferro, N. *The Prehistoric Pottery found in the Hypogeum at
 Hal Saflieni*. Annals of Archaeology & Anthropology. Unv. of
 Liverpool. 1910.

My Taylour, W. *The Mycenaeans*. London 1964.

Sk.MM Trump, D. H. *Skorba, Malta and the Mediterranean*. Antiquity
 35 : 300. 1961.

SKB Trump, D. H. *Skorba*. London 1966.

NCM Trump, D. H. *The Neolithic of the Central Mediterranean*. Text of
 lecture given at the Conference of the British Association for the
 Advancement of Science. September 1969.

 Trump, D. H. *Archaeological Guide to Malta*. London 1972.

Ug. Ugolini. *Malta Origini Della Civilta Mediterranea*. 1935.

 Woolner, D. *Graffiti of Ships at Tarxien, Malta*. Antiquity 31 : 60.

 Zammit. T. *The Hal Saflieni Prehistoric Hypogeum at Casal Paula
 Malta*. First Report. Malta 1910.

 Zammit, T., Peet, T. E., and Bradley, R. N. *The Small Objects and
 the Human Skulls found in the Hal Saflieni Prehistoric Hypogeum*.
 Second Report. Malta 1912.

PMTT Zammit, T. *Prehistoric Malta*. The Tarxien Temples. Oxford 1930.

PRMI Zammit, T. *The Prehistoric Remians of the Maltese Islands.* Antiquity. 1930.

Photographic Acknowledgments. *The publishers gratefully acknowledge the following for permission to reproduce illustrations: The National Museum of Malta, Valletta; The Malta Government Tourist Board; and the author.*

INDEX OF MOTIFS

Numbers in italics refer to illustrations

INDEX